TOBI KAHN

———

MICROCOSMOS

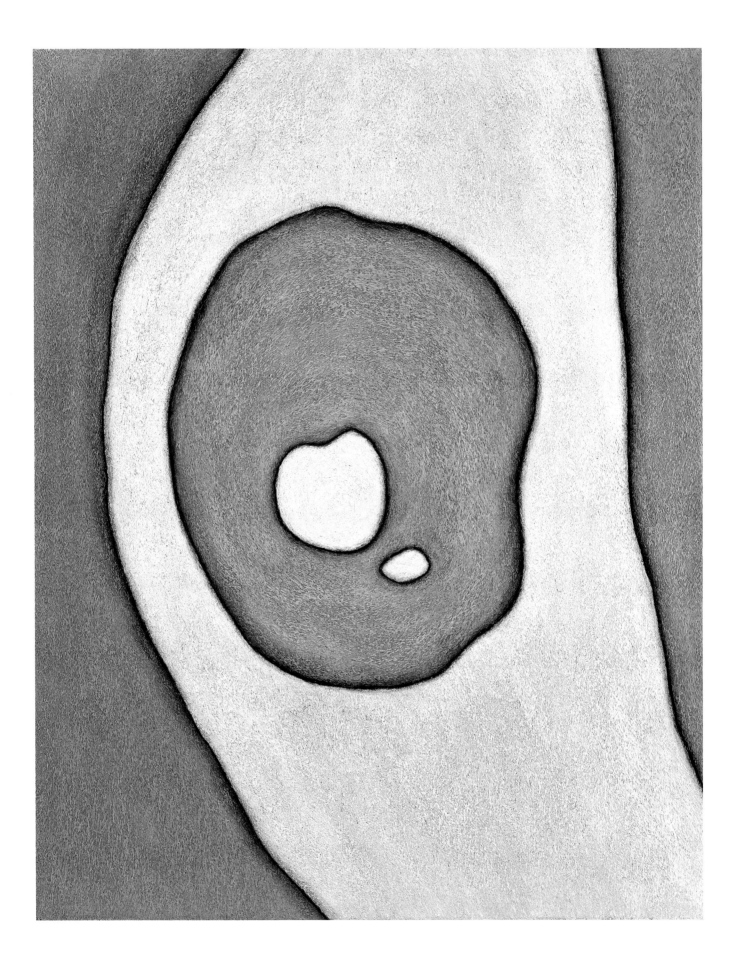

TOBI KAHN

———

MICROCOSMOS

Essays by Saul J. Berman, Evan Eisenberg, Mark L. Tykocinski

Published by Yeshiva University Museum, New York

This catalogue has been published with the generous
support of Leonard A. Kestenbaum; Aryeh and Raquel
Rubin Foundation; Carol and Arthur Spinner; Jack and
Phyllis Wertenteil Foundation; and other funders.

DESIGN
Elizabeth Finger

EDITOR
Nessa Rapoport

EDITORIAL COORDINATOR
Sharon Florin

PHOTOGRAPHY
Nicholas Walster

PRINTING
Cantz, Germany

"Defining Multiplicity: A Midrash on Creation"
by Saul J. Berman.
©2002 Saul J. Berman

"Planes of Creation" by Evan Eisenberg.
©2002 Evan Eisenberg

"Landscapes and Bioscapes" by Mark L. Tykocinski.
©2002 Mark L. Tykocinski

Poems on pp. 22 and 32 by Felice Kahn Zisken.
©2002 Felice Kahn Zisken
*Felice Kahn Zisken is a poet who made aliyah from
New York to Jerusalem in January 1971.*

Photography by Nicholas Walster. ©2002 Tobi Kahn

COVER
Yde, 2001 (detail)
cat. 28

FRONTISPIECE
Ykhon, 2001
cat. 23

CONTENTS

———

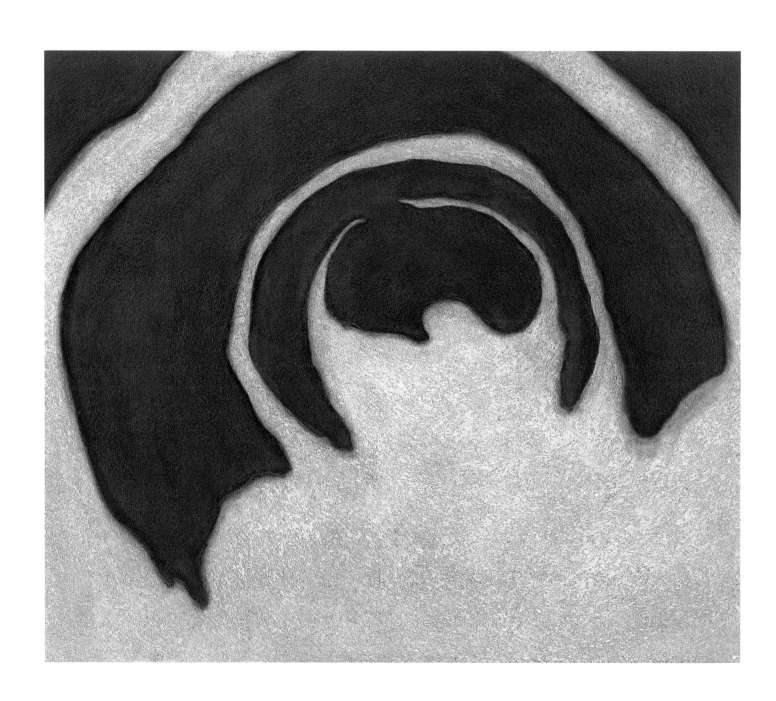

QINTA cat. 10

PREFACE

———

The Yeshiva University Museum is proud to present *Tobi Kahn: Microcosmos*, an exhibition of paintings based on the biblical narrative of creation. Tobi Kahn is an internationally acclaimed painter and sculptor. His work has been shown in over 30 solo exhibitions and over 60 museum and group shows, beginning with his inclusion in the 1985 exhibition at the Guggenheim Museum, *New Horizons in American Art*. As a graduate of Yeshiva University's Manhattan Talmudic Academy high school, the artist has returned to his roots, to the place where his knowledge of the Bible developed. It was at Yeshiva that Kahn continued his immersion in the study of sacred texts and their manifold interpretations.

Kahn is the product of a strong family heritage grounded in Jewish tradition and profoundly affected by the Holocaust. He does not treat the Holocaust directly in his work but knows he has been shaped by the murder of his relatives and his grandparents' rebuilding of their lives in the United States:

I have tried to create work that seems unaffected by time, work that appears to have been here always. I am continually aware of time's passing, of the possibility of loss, an abrupt reversal of safety. In the face of the word's instability, I want to reveal those elements that are transcendent, not the evident reality but its essence, the inherent vitality that is possible. I want to transmute the darkness, salvage it for meditation without denying its power, revealing the spirit of our inner lives — mysterious, resonant, a sanctuary in a still struggling world.

It is particularly appropriate that Tobi Kahn present this body of work here because his rich cultural background is based on *Torah* and *Madda*—sacred and worldly

knowledge in a unique combination, promoting an active contribution to the community while deepening the understanding and practice of our tradition. This exhibition of Kahn's work encapsulates the mission of Yeshiva University, connecting art, science, and religion in the service of society through its various branches. These include the Museum, the undergraduate men's and women's colleges, Cardozo Law School, Albert Einstein Medical School, and the Sy Syms School of Business.

Kahn has infused the visual elements of the biblical tradition with his own spirituality. He explains: "Although Judaism has emphasized words, language, and interpretation, I have found the visual elements of the tradition equally illuminating. For me, the life of the spirit is integrally bound up with the beauty of the world, with the rituals and symbols that are a Jewish medium to transcendence. Like language, what we see can be a benediction."

These paintings allow the viewer to see himself in relation not only to the world of nature but to an inner world, leaving room to "renew, always, the works of creation," in the words of the morning prayer describing the Creator.

Kahn has chosen to capture the paradoxes of nature, the seeming simplicity of its design and the infinite complexity of its structure, reducing them to minimal formations that reflect sky, land, water, molecules, cells, blood, and the nuclei of life itself. The names he has given his paintings suggest Divine acronyms that invoke passages from the text of Genesis and allude to Hebrew words. His paintings become metaphors for creation. This artist illustrates the beginnings of the universe with the sparest of means. In so doing, Tobi Kahn demands both interpretation and participation; his work becomes the vehicle through which we can reach our own sacredness.

The Yeshiva University Museum would like to acknowledge the support of the New York City Department of Cultural Affairs, the New York State Council on the Arts, the Institute of Museum and Library Services, and the Smart Family Foundation.

The artist would like to thank Rabbi Saul J. Berman, Evan Eisenberg, and Dr. Mark L. Tykocinski for their evocative essays; and Felice Kahn Zisken for her poetry. He also thanks his studio assistants, Ray Abary, Joel Haffner, Christian Kent, Noah Landfield, and Mark Stack, for their dedication to this project. He is most grateful to Elizabeth Finger for her elegant design; Sharon Florin and Nessa Rapoport for their scrupulous editorial work; and Nicholas Walster for the quality of his photography.

REBA WULKAN
Contemporary Exhibitions Curator
Yeshiva University Museum

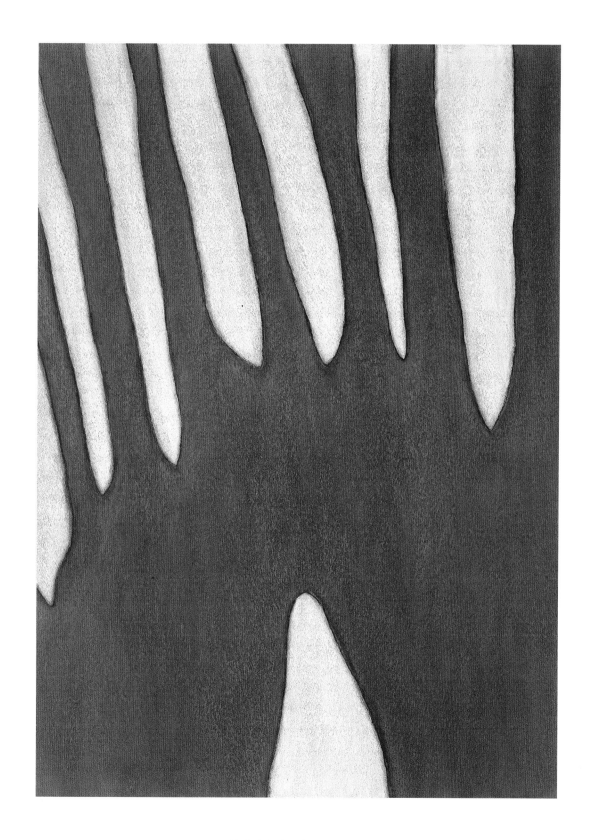

YCALI II cat. 8

WORKS OF NATURE ARE ABSTRACT

A Way to Look at Things, 1925

Arthur Dove

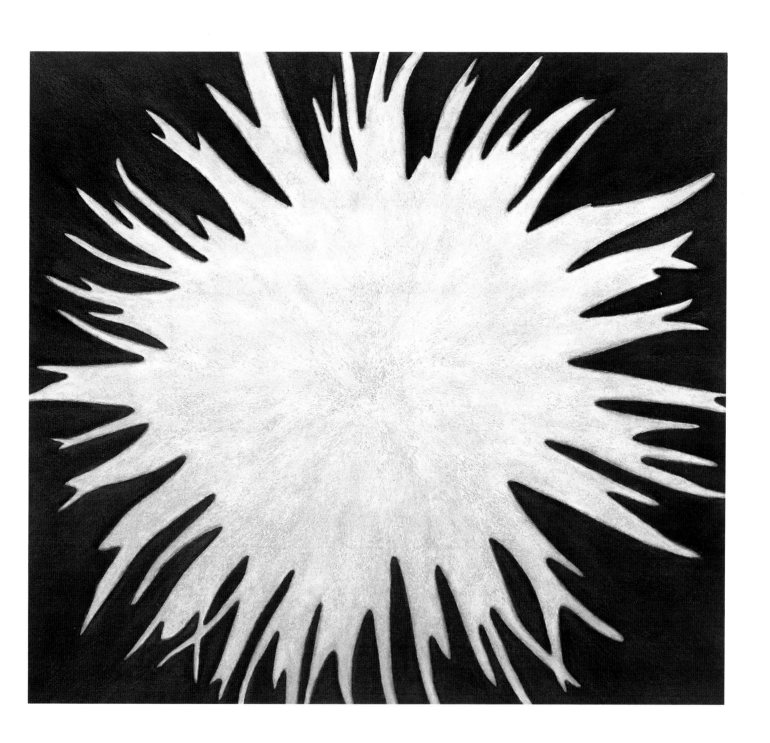

AHLOM cat. 25

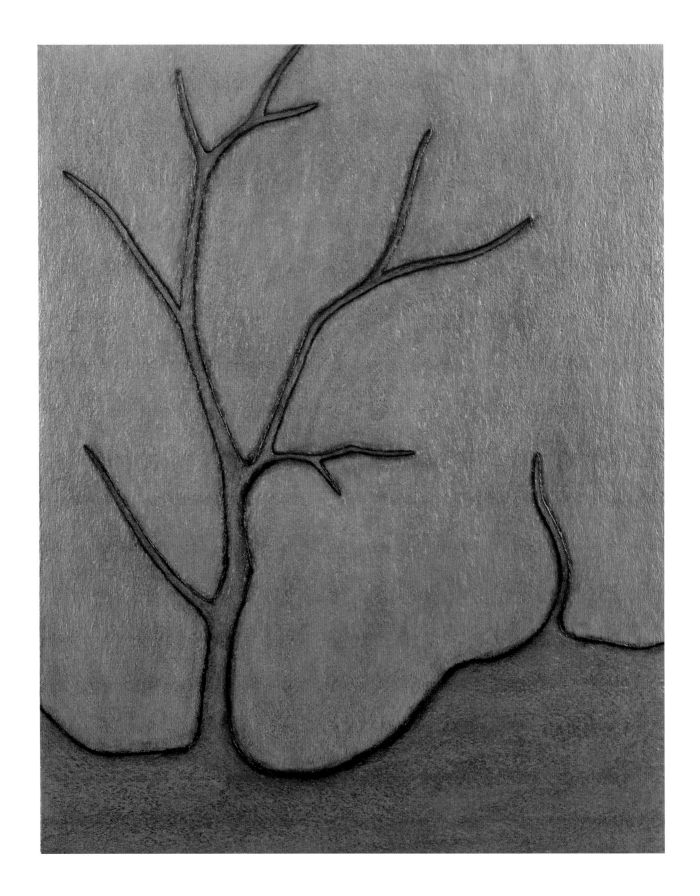

YSRA cat. 30

PLANES OF CREATION

Once on an ice-bound pond in the Catskills I saw the shadow of a naked tree. But I couldn't find the tree. The grey, branched figure was not an absence of light but (I brightly surmised) an absence of ice: the fault lines of ice breaking up.

Tobi Kahn's *Ysra* shares that ambiguity. It might be a bare tree against a leaden sky; it might be a ramifying crack in gravid, granular ice.

Growth and dissolution can have the same geometry. Nor is their substance so readily distinguished: without the thaw, the tree won't grow.

As a painter in words, let me draw on my own experience. A book or essay can grow by accretion, facts and ideas attaching themselves at the points of growth, forming branches and sub-branches. That phenomenon is itself branched: the expansion can be fairly even, like the growth of a bacterial culture in the Eden of agar-agar; or one branch can take off like forked lightning, leading the author into regions never authorized. At times the pace may feel glacial, at others dizzying in its twists and turns — the mind seeming to expand as rapidly as the universe, red-shifting madly.

Or a work can grow like a fissure — can start as a neat dichotomy and then, as it moves deeper into the material, waver and shiver and throw out nervous, probing fingers until, perhaps, everything you thought you knew melts away. Not always a pleasant feeling: for everything you thought you *were* may seem to be melting, too. As preconceptions crack up, the self — that fondest preconception — may threaten to do likewise, as may other structures entailed in the creative act, such as contracts, careers, and marriages.

Whether it is all worth it is an open question, but every act of creation worthy of the name takes place on thin ice — or on the open water that is revealed when the ice breaks up.

Protein's origami, the protean shape-shifting of microbes, the busy, Berkleian choreography of cells in a growing embryo — involved and elusive though each of these is, the topology of artistic creation exceeds them all.

It takes place on so many planes, in so many dimensions. The world of armchairs, beetles, and rock outcroppings. The realm of people and their relationships. The plane of a stretched canvas, a sheet of paper, a computer screen. The ocean of air through which sound moves. The furrowed fields of the artist's brain, where neurons fire raggedly from the trenches. The mental or metaphysical space in which forms and ideas bump, grapple, and aggregate. The curved space-time of the bodies of women you hope to impress. The market. The egosystem.

The place where these planes intersect — where these dimensions implode upon each other — is a place of terror. Of joy, perhaps (the artist repeats this like a mantra until he tricks himself into making it true), but of terror, undoubtedly.

How could it be otherwise?

Each of the planes that meet in the moment of creation (and in the many moments in which creation fails to happen) is riddled with depth charges of emotion, and as these charges go off the artist has little sense of what has hit him or from what quarter. Nor does he know if the charge will be transmitted to his audience, or depends rather on private contingencies (the word "duck," for instance, drawing in its subconscious wake a "bill" that is overdue).

The almost physical sense of fields of force, of shapes that nourish or infect, protect or threaten, is deeply unsettling when you have no idea whether they are in the work, in the world, in your head, or in several places at once. Inside and outside, figure and ground, shield and menace are desperately muddled.

Tobi Kahn's images call up this terror like no others I know. They keep it rumbling just beneath the surface of consciousness, in the quarry where writers' blocks are hewn.

———

In *Dariah*, a blue finger-like shape penetrates a sheltered space. Fertilization? Invasion? If the thing penetrated seems more like embryo than egg, might this be amniocentesis? If so, is that good or bad? Does the artist really want to know exactly what is happening inside?

In *Nahn*, one biomorphic shape erupts within another. Are we seeing a microbe being devoured from within by a parasite? A man consumed by anxiety? Or the artist's soul, leaping for joy, inside his stooped and silent frame?

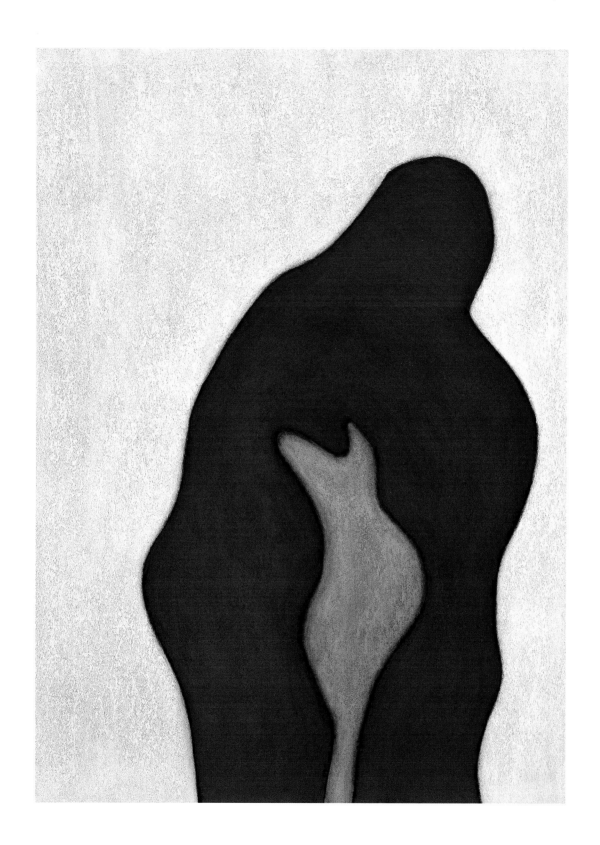

NAHN cat. 24

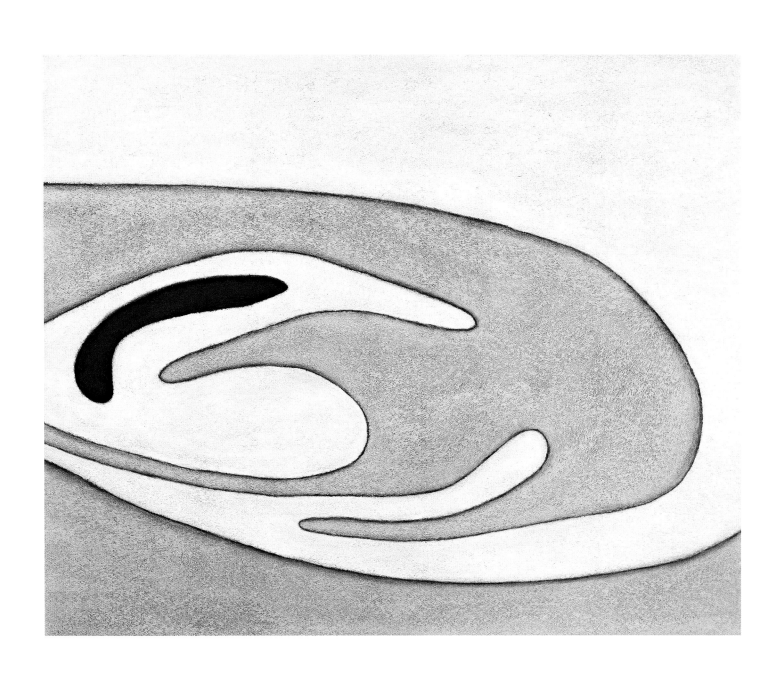

E L Y C cat. 27

It is easy to see, in Kahn's pictures, forms that look like cells. But it is hard, when we see forms within those forms, to tell if they are parasites or organelles. That is as it should be, for scientists now believe that the chloroplasts, mitochondria, and perhaps undulipodia of eukaryotic cells evolved, billions of years ago, from bacteria that meant their host microbes no good.

Artists, for their part (I use the term in the generic sense, to include even such lowly creatures as writers), do not need Lynn Margulis to tell them that the most threatening ideas can become the power plants, engines, and propellers of the finished work — if, that is, the artist knows how to tame them.

In biology, it can be hard to tell processes of health from those of disease, or protection from menace. Perhaps there can be no final judgment, for disease, parasitism, and predation are creative: without them, evolution would be a sluggish affair. Similarly, for the artist it is hard to know, in the moment, whether an inspiration is real or bogus, muse or succubus. Hard to know afterward, even.

———

Many of the paintings are topological puzzles. We flail, and fail, to orient ourselves: what is inside, what out? In *Elyc* the dance of figure and ground is so involved that it becomes a swirl. Here, as elsewhere, Kahn's framing withholds key information. We have a sense of having zoomed in to some arbitrary level of magnification: if we zoomed in further, or zoomed back, inside and outside might reverse. Which is just how it is in nature: the outside of a cell is the inside of a blood vessel, and so on.

Quite apart from point of view, the notion of an organism as a discrete entity, with definite boundaries, does not hold much water. Is the air in your lungs inside you or outside you? Are the microbes in your gut part of you, or not?

The space where art is made is even more ambiguous. Where, after all, is the work that I am working on? Is it inside me? Is it out in the world? Or is the world inside me — do I, like Whitman, contain multitudes?

Consider two pairs of closely related images. In *Yrth*, I see ideas nurtured like eggs in the glowing amniotic fluid of the artist's mind. At the same time, those shapes seem to be bubbles of outsideness treasured within, as vacuoles are bubbles of fluid within the cell. In *Lei-Orna*, the eggs are trapped within a self that is itself egglike, entirely closed, yet fragile perhaps, washed-out and wary. It seems to be stranded on the kitchen floor and trying to roll away. (This is one of many images in which pearly whites and forms suggesting

bone or enamel make us strangely nervous, the anxieties of dentistry and bone scans merging with a vision of our fossilized end.)

Qinta conjures, for me, the artistic self struggling to defend itself, erecting concentric walls of defense against the outside world, but failing to close the circle. *Almah II* is more benign (for me, the only wholly benign image in the show). Here is an artistic spirit that shelters without containing, that shapes without constraining. An ideal parent for our brainchild. The holy spirit enfolding our work with its wings.

Maybe I'm overreading. Maybe *Almah II* is just the gilded transcription of the print left by Kahn's morning coffee on one of his sketches. Maybe it's a solar eclipse. But the title is one of the few that seems to have a clear denotation. In Hebrew, *almah* means maiden. This girl, though, is no walled garden. She is open to the world.

The artist can easily become trapped within his own walls. He cultivates his garden, nurtures his art, gestates, brings the idea to fruition. But the feeling that one's creative world is really interior, self-enclosed, an island, can lead to isolation, sterility, constipation—it's in there, why won't it come out?

In a famous story, a scholar goes to visit a Zen master. The scholar launches into a long disquisition meant to show off the depth of his knowledge. As he speaks, the master pours tea into his cup, and keeps pouring, until tea courses across the table and over the floor. When the shocked scholar protests, the master says, "How can you expect me to fill you up, if you don't empty yourself first?"

In a way, the story is misleading. We do not empty ourselves in order to be filled; we are always filling, always emptying. (The Psalmist: "My cup overflows.") Such is our nature not only as artists, but as living things. Walls and membranes are conditions of life, but no living system is closed; all are shifting forms through which matter and energy continually flow. In the more extreme readings of Prigogine and Bataille, life on earth is a "dissipative structure," its myriad forms merely ways of dispersing the superabundant energy of the sun.

The artist is a vessel not like a teacup, but like a boat. Otherwise, his tempests will be domesticated. We don't enfold our art with our wings: we are beating on the wind of the spirit. This is afflatus—not a filling up, but a lifting up. Like Ezekiel's: "Then a wind lifted me up..."

———

Since they first stood sandal-toe to sandal-toe in debate, philosophers have disputed whether creation comes from something or from nothing. For artists, the question is easily resolved.

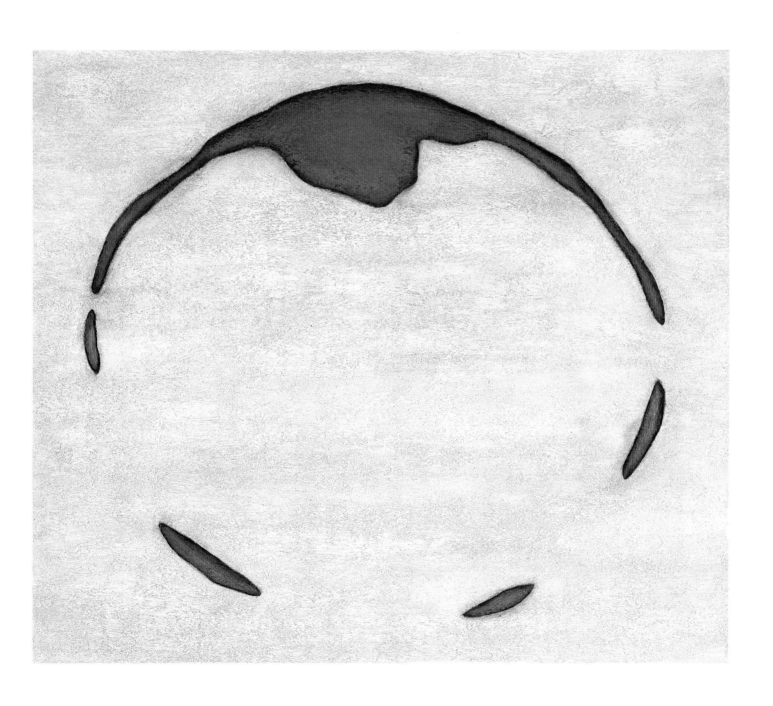

ALMAH II cat. 2

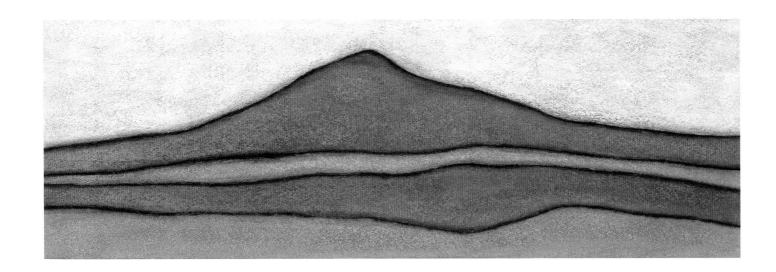

ALKAH cat. 17

When I write, I may seem to be assembling the story from bits of stuff that I know; but what is really formative is what I don't know. Not what is clear and present, but what is cloudy and absent draws me on.

In Judaism, the longing for what is missing or hidden is the creative force. While Buddhists aspire to a godlike freedom from longing, the Jewish God shatters his own unity so that he can have something to long for.

———

The names are as mysterious as the images. Some sound Hebraic, some Polynesian, some Betelgeusean. My guess is that they are near-random permutations of letters or syllables of the sort used for mystical purposes in the tracts of Abraham Abulafia. Words create the world. Though God's words may be privileged, all words retain creative power. (*Abracadabra* may be rusty Aramaic for "I will create by means of the word.") Hebrew letters are the fundamental building blocks of the cosmos, the quarks and gluons of mystic physics.

The aleph-bet, unlike the alphabet, holds glimmers of its pictographic past. For a Hebrew speaker the sheltering form of the letter *bet* still evokes *bayit*, a house. Scan Kahn's pictures in rapid succession and you may feel that here, too, is an aleph-bet of creation. (A more exact parallel might be Chinese characters and the radicals that compose

them, but as Kahn is not Kung or even Khan we'll stick with the aleph-bet.) Forms recur and are recombined in a way that feels as much like spelling as painting—especially if we bear in mind another meaning of "spell."

One almost feels as if changing the sequence in which the images are hung might change their meaning, or even our fate.

———

As long as I'm speculating, I will guess that Kahn was lured into the world of tiny things by the photomicrographs of Roman Vishniac. I will further hazard that he came to these by way of Vishniac's images of the "vanished world" of pre-war Polish Jewry.

Both worlds are invisible to the naked eye. One requires magnification, the other memory, but those functions are not as different as they seem.

The world of Polish Jewry is now very small, both because it has been decimated (though "deci-" is the wrong prefix) and because it has receded into the past. Vishniac magnifies it. By the same token, to magnify—to search within, to probe the fine texture of things — is to see the past. The smaller the scale, the clearer our ancient kinship with all living things: for that matter, with all matter.

But the token has another side. Peering at tiny, hidden things — sperm and egg, seed and bud, embryo, dividing cell, differentiating tissue — is also a way of seeing the future.

"Magnified and sanctified be His great name"— so begins the Kaddish. The ancient rabbis did not have microscopes, but let us, in their spirit, misconstrue them. Magnification and memory are both ways of bringing hidden things to light. They are ways of hallowing God's name by making visible the holiness that gets lost in the holes and cracks of the present and the dark tunnels of the past. And they remind us that in these hidden things — these inchoate, disturbing shapes — lie the secret of creation and the germ of the future.

Vishniac is saying Kaddish. So, in this spellbinding hymn to creation, is Kahn.

EVAN EISENBERG

———

Evan Eisenberg is the author of *The Ecology of Eden* (Knopf, Vintage) and of *The Recording Angel*, which will be reissued in 2003 by Yale University Press. His writing on nature and culture has appeared in *The Atlantic*, *The New Republic*, *Natural History*, and *The New York Times*.

———

HOW TO SING THE SONG

OF THE LIGHT AT DAWN

COMING FROM THE EAST?

Lashir

Felice Kahn Zisken

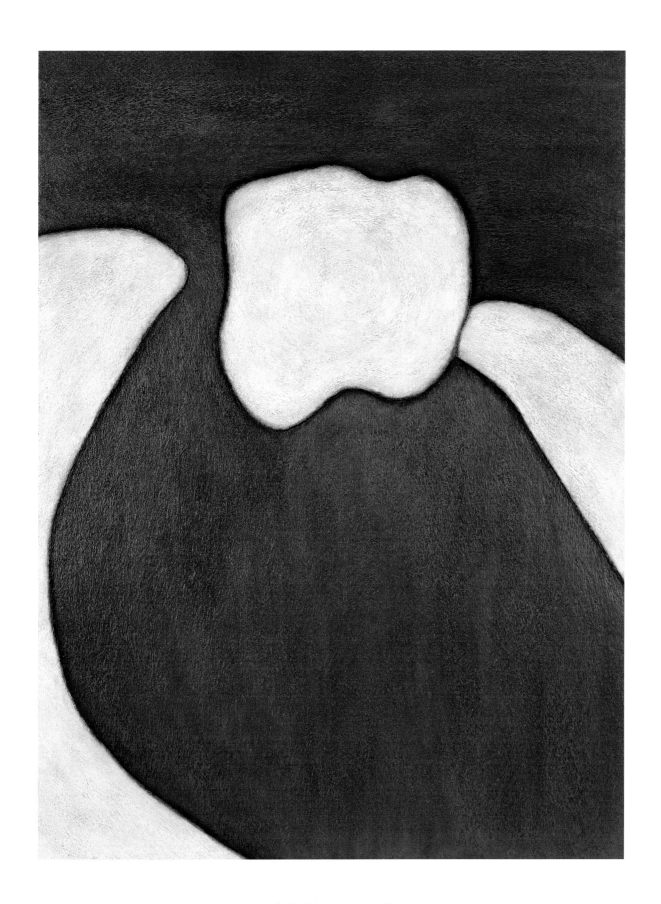

AACHA cat. 26

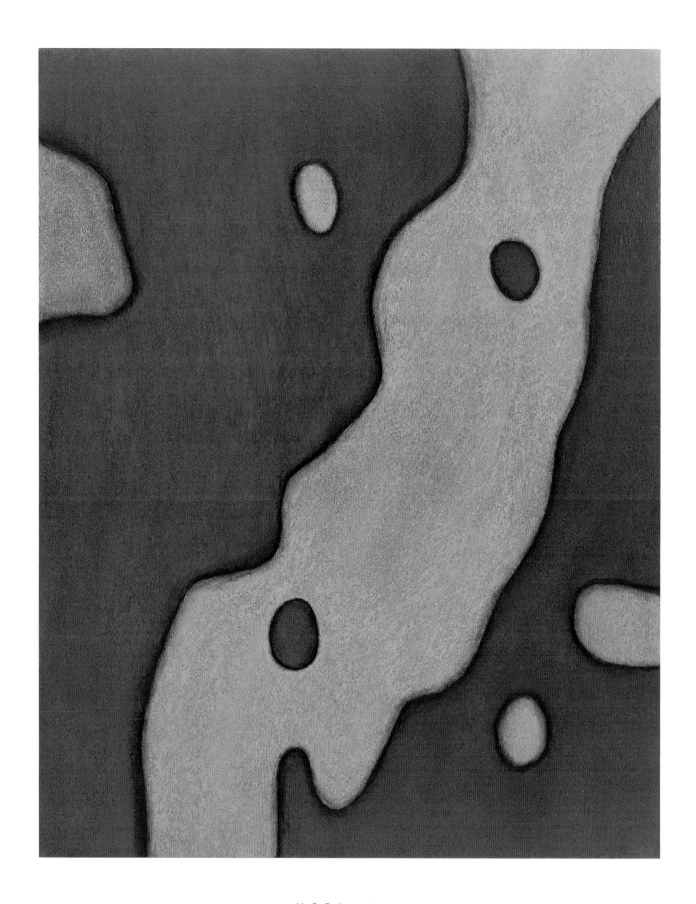

MOEA cat. 20

LANDSCAPES AND BIOSCAPES

———

Meandering through my laboratory one day, Tobi eyes some electron micrographs scattered across a bench top.

"Mark, what are those?"

"Pictures of cells and tissues, in their ultrastructural detail, on a scale of millionths of a meter."

"Those are visually amazing!" Tobi exclaims.

Months later, his first "biomorphisms" emerge, paintings inspired by the intricacies of cellular fine structure. I see cells; Tobi sees forms.

———

Form for Tobi Kahn is universal. As he effortlessly traverses landscapes and "bioscapes," the two soon merge — and what results is a unity of form. The original inspiration for a painting becomes incidental, a mere curiosity. Imagination takes over, with the images on canvas inviting, or even demanding, alternative interpretation. Is *Almah II* an archipelago or a neuron? Does *Moea* portray the banks of an island-dotted river or cells in apposition? Is *Ruota* a vision of fjords or Purkinje fibers?

Kahn's paintings transcend the immediate and emphasize the possible. By creating conceptual and aesthetic bridges between land and life, Kahn highlights their shared structural elements. Panoramas of land and water give way to cells and surrounding matrices; cellular ultrastructure evolves into land structure. Suddenly, there is a merging of geologic and biologic processes.

And while the forms Kahn captures are frequently referred to as "elemental," they are anything but simple. His forms evince complexity in their intricacy and their two-

and three-dimensional layering of structure. Elemental forms are not merely circles and triangles and squares. Rather, they are transformed into complex shapes, remarkably rich in representation and connotation. For Kahn, the elemental has a depth of contour, a complexity of shape, that is recapitulated at many scales and in many systems.

The scalability of Kahn's forms is evident even within the biological realm. Is *Ician II* a developing plant gamete or cytoplasmic processes in proximity? Is *Dariah* a developing fetus or intracellular organelles? Is *Jama* the profile of a woman's body or fibroblasts touching? Organismal structure parallels cellular ultrastructure—human forms interpolate cellular forms and back again. The same forms reemerge at different scales; complex "elemental" forms are reiterated in different contexts. The exploration of form in one realm tells us about form in other realms, an equivalence flowing from a union of the perceptual and the actual.

Yet Kahn's exploration of form goes well beyond the study of its universality and the recapitulation of shapes. His paintings teach us about form per se, and, in so doing, reflect intriguing facets of that which is represented. One is the dynamism of boundaries.

––––––

Bicycling side by side on Menauhant Road, Tobi and I are absorbed by the beauty of the unfolding Cape Cod coastline on a late summer afternoon. Suddenly, he stops and flags me over to the side of the road.

"Mark, in the distance, what do you see?" He is pointing toward the sea on a cloudless day.

A bit puzzled, I say: "Sea and sky—I'm not sure what you're getting at."

"No, look harder, there's something else, at the horizon, a line of a different color, separating sea from sky."

Peering into the distance, I watch as the horizon line slowly emerges. Tobi's image now becomes mine—the boundary between water and air is generative, a site of creation.

Weeks later, when I visit his studio, he shows me a series of paintings on which he had been working for some time, depicting the sea-sky horizon.

––––––

Forms are bounded. Kahn devotes much attention to boundaries.

His paintings capture, almost obsessively, that which is emergent at boundaries. In Kahn's hands, a boundary is much more than a neutral interface where object meets background. Boundaries are sites of creation and worthy of exploration.

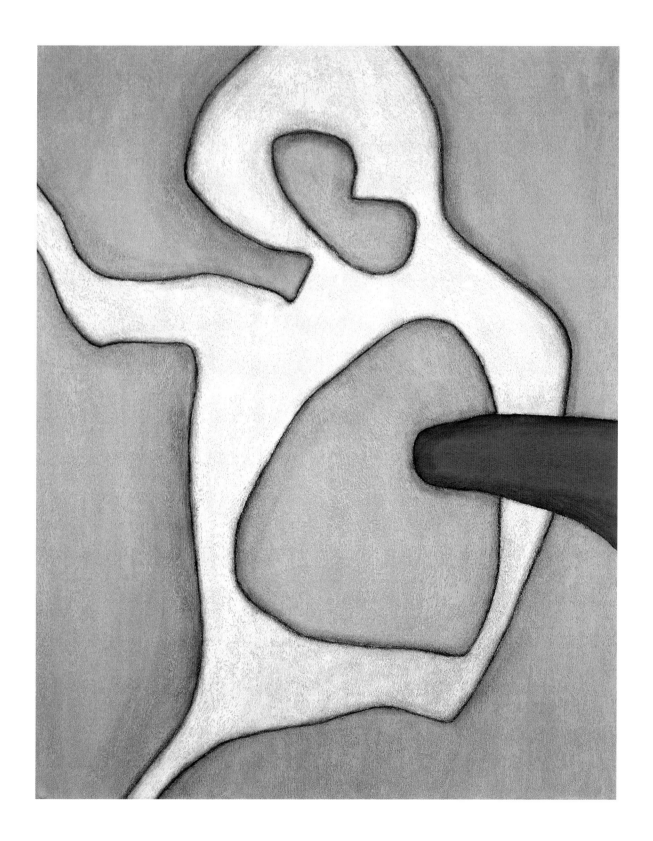

DARIAH cat. 4

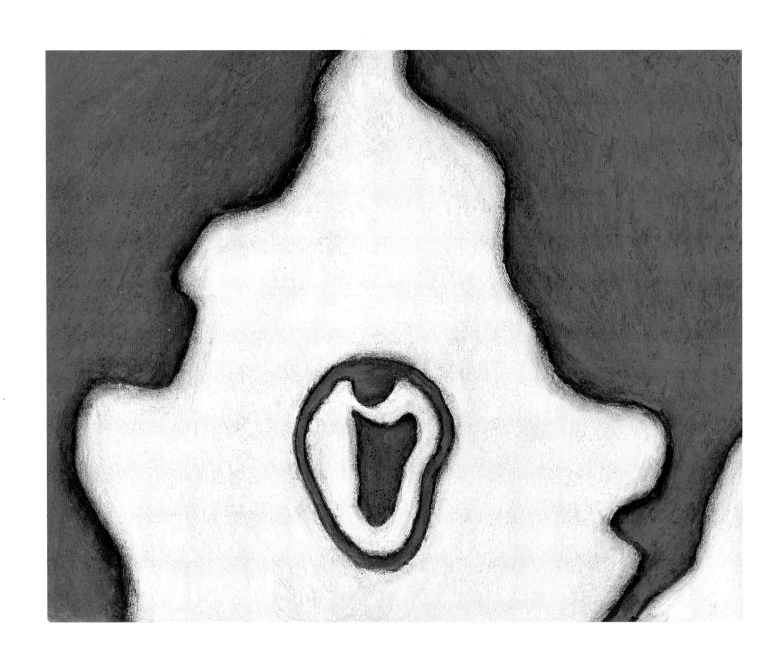

REKH-EYM cat. 5

On the cosmic scale, where empty space meets black hole, an entirely new physics takes hold. On the terrestrial scale, where sea meets sky at the horizon, new images materialize. Biological boundaries, too, are dynamic. Living things can be viewed as a cascade of boundaries, the organism bounded by its surroundings, tissues from other tissues, cells from other cells, organelles from other organelles.

Scientific findings in recent years point to a wealth of new phenomenology at the boundary where cell meets cell, or where protein meets protein. At the boundaries between cells, surface proteins reorient themselves, and macro-molecular complexes assemble to perfect cellular communication and signaling. At the boundaries between the constituent proteins themselves, new protein conformations arise, creating new forms simply by touching each other.

So, too, are boundaries prominent in Kahn's biomorphic images. Where cell meets matrix, new imagery is created. In *Ahvir* and *Rekh-Eym*, boundaries dominate the very forms they delineate.

———

After several years of research, I find myself preoccupied with designing novel proteins that can incorporate into the surface membranes of cells, functioning, in essence, as "protein paints."

Following my delivery of a plenary lecture at a national meeting in Atlanta, the editor in chief of The American Journal of Pathology approaches me. "Those paintings you interspersed in your talk were wonderful. Do you think we could use one of them?"

And so the cover of the January 1996 issue of The American Journal of Pathology has a new look — featuring for the first time a painting, one of Tobi's biomorphic images.

Our lives intersect in yet another way. Both of us — the artist and the scientist — are painting cells.

———

At one level, Kahn's paintings are representational — abstracting from what exists. At another level, they are conjectural — pointing to what might be created.

For me, one of the attractions of painting therapeutic cells was the idea of using biology's own tools to improve upon itself. This idea is at the heart of the genomic revolution and modern molecular medicine. The cells and their proteins represent the actual; painting points us to the possible. The beauty of living systems is that they are self-instantiating, carrying within themselves the tools to create ever greater variety and complexity. The beauty of G-d's creation is that it possesses within itself the capacity to create anew.

Kahn's work goes beyond mere reductionism into elemental forms. Through painstaking layering of color, Kahn achieves a material depth in his painting that adds new dimensions to the initial forms. Images, such as those in *Ayukah*, *Jama*, and *Ysra*, emerge from the canvas through the artist's patience.

But what is especially interesting is Kahn's approach to multi-dimensionality. Through simple, repeated steps, layer by layer of elemental patterns, he creates depth. Simple rules, when implemented iteratively, generate great complexity. This is true of biological systems, and it is true of Kahn's paintings, which reflect these systems.

We now know that living organisms arise and thrive using fewer genes than had once been thought possible. Given the apparent genetic redundancy in most organisms, we have yet to ascertain the precise minimum number of genes that would support life. Despite the richness of the protein lexicon, there are surprisingly few types of protein functions. From simple rules and recapitulated patterns, the wonder of life arises. Undoubtedly, complexity generated by relatively few elements reflects underlying processes that operate in a multi-dimensional framework. Functional multi-dimensionalism is at the heart of super-string theory, the closest physicists have yet come to a "theory of everything." Likely, a "super-biotic" theory will be needed to explain the multi-dimensional framework that is life.

———

Kahn's paintings reflect the beauty of earth, the beauty of life. They analyze form and tell us about its universality, its boundaries, its dimensionality. His paintings are inspiring, as we address pressing questions of modern biology for the coming century. How does form take shape? How does form translate into function? How can we change form to create new function?

Creativity is as much the ability to see what others overlook as it is the generation of something new. Abstraction, in Kahn's hands, is not simply extrapolation from existing reality but a creative act.

MARK TYKOCINSKI

———

Dr. Mark Tykocinski is Professor and Chair of the Department of Pathology and Laboratory Medicine at the University of Pennsylvania. A graduate of Yale University and New York University School of Medicine, he later trained in molecular immunology at the National Institutes of Health.

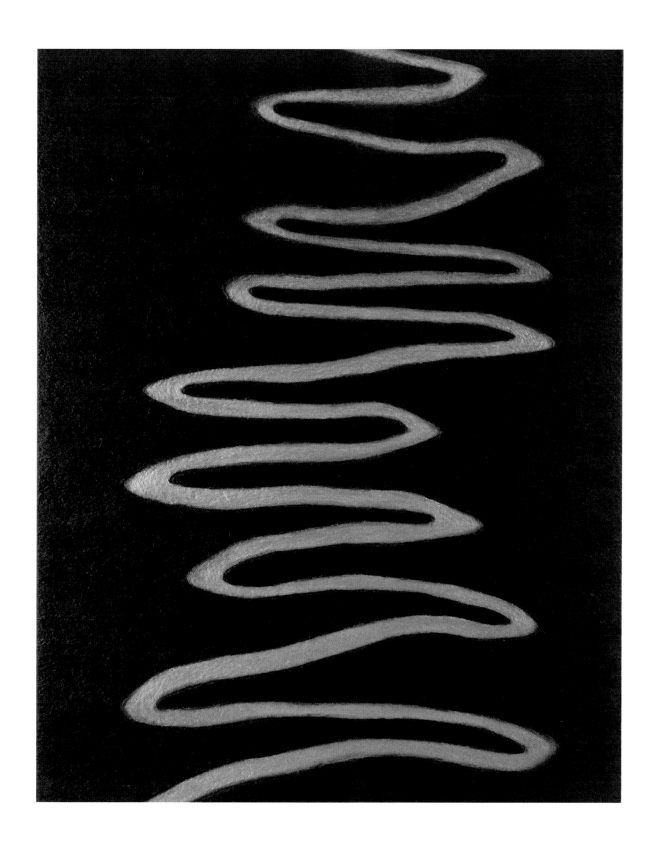

POMEGRANATE NEARLY BURSTING

INSIDE COMPASSION

MOVEMENT

BELLS RINGING IN A CLEAR VOICE

Rechem

Felice Kahn Zisken

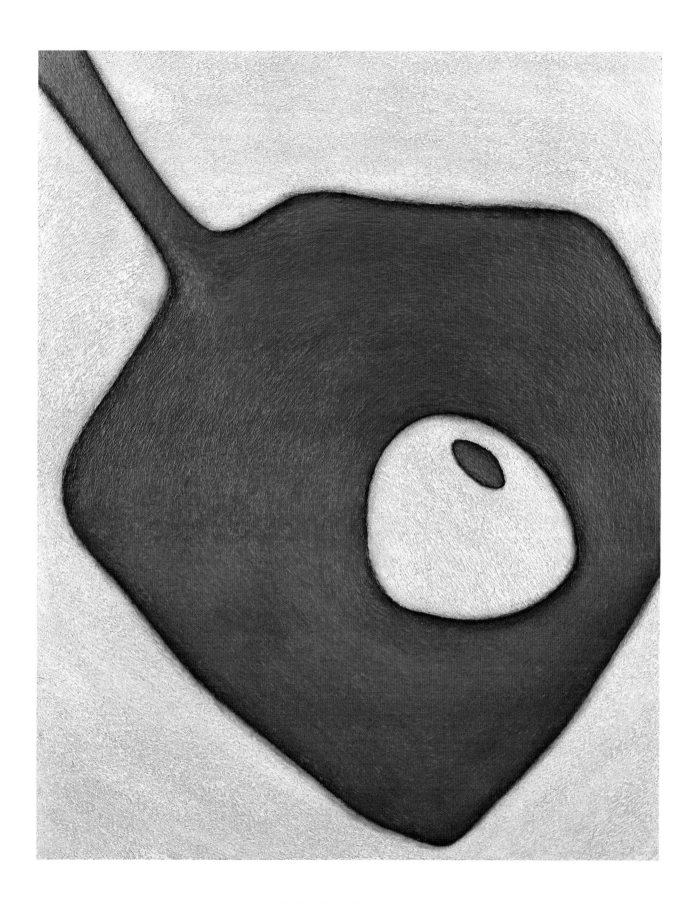

UAM - MANA cat. 35

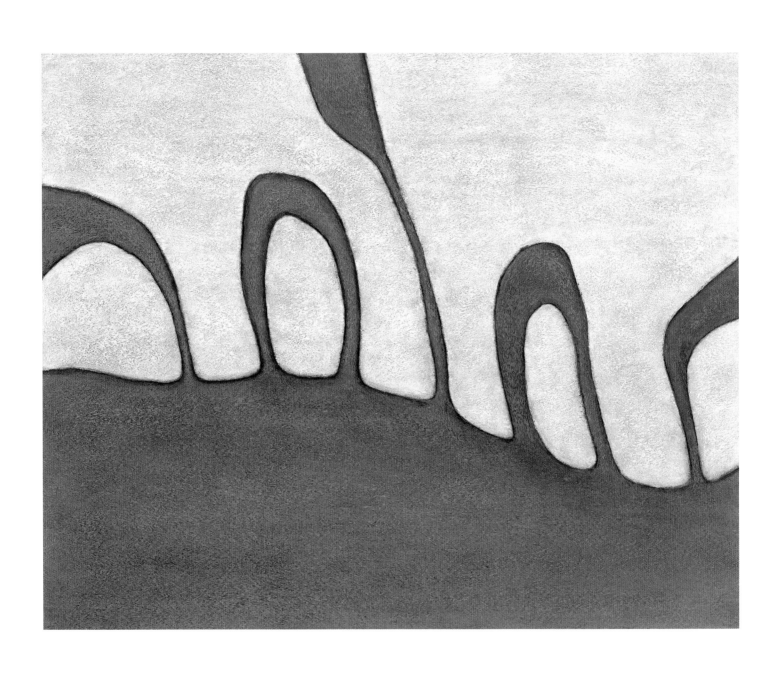

ORTYA cat. 34

DEFINING MULTIPLICITY

A MIDRASH ON CREATION

―――

In this exhibition Tobi Kahn has given us an extraordinary gift, a visual-spiritual midrash (interpretive commentary) on the biblical narrative of creation.

The first chapter of Genesis provides a series of verbal pictures of the processes by which God brought the universe into being. It is a sparse account. With the use of twelve active verbs in only thirty-one sentences (Genesis 1:1-31), the Bible portrays in five stages the passage from void to the world as we need to know it. From the biblical perspective, these stages form the paradigm for the process of human productivity in our partnership with God, in the continuing effort to implement God's goodness in the world.

The five stages are:

1. The creation of matter in its essential forms;
2. The expansion of the forms;
3. The setting of boundaries to limit expansion, thus allowing diversity;
4. The naming of matter in its particular form; and
5. The evaluation of whether the productive process achieved its purpose.

Kahn does not attempt to represent these stages of creation, but his complex flowing figures evoke in the viewer an awareness of the complexity and dialectic within each.

In this body of work Kahn entices us into a view of the essential forms that shape creation. These are not sharply defined, subatomic elements, but the soft forms of which human and animal bodies and vegetation are constituted in our visual perception of them. We see tubes of varied length and thickness, uncertain of their boundaries, moving in all directions (as in *Ycali II* and *Ortya*.) We are introduced to the emergence of ovals and circles struggling to become perfectly formed but never quite achieving the symmetry suggested

by their ideal forms (as in *Almah II* and *Yrth*). The corners of triangles are somewhat rounded, yielding the angularity of their usual representations (as in *Yde* and *Rekh-Eym*).

The generation of these forms, Kahn suggests to us, is the critical first step of creation. And that first step is gentle and loving, the forms caressing the lines out of which they emerge. Creation is not violent; it is the loving touch that molds the intersection of form and form for the sake of function and purpose. This is his midrash on the Divine acts of *bara* (created) and *assah* (made).

Kahn's artistic method of forming his images by multiple layers of paint provides another insight. Our perception of the essential forms, he implies, is the beginning of human understanding of the reality that is subject to our control and available for our productivity. These forms are the matter out of which we can make the next stages of loving being. The artistic process, Kahn teaches us, is a paradigm for all creative engagement.

The essential forms having been brought into existence, they need to replicate, to reproduce in order to fill the earth. The free, unconstrained, sometimes explosive replication of shapes and forms is the theme of other works in this exhibition. We are made to feel the joyous energy of this reproductive process as multiple forms sprout from one another (as in *Ruoata*), or as an explosive sprouting of common forms from a single source is captured at its most intense moment (as in *Ahlom*).

The reproductive process is further evoked in the works where shapes divide, bearing smaller versions of themselves (as in *Ykhon*). Prominent in these is a fetal shape, usually enfolded by the larger form as if in a protective embrace. But the newly emerged form is never a precise replication of the shape from which it divided, testifying to the infinite capacity for diversity embedded in the primal forms (as in *Dariah*). Nor does the division result in alienation, as the fetal form remains partially or fully within its source.

The teeming of similar forms, not yet directed toward the formation of complex entities, nestling within or against or in proximity to one another, allows us to feel the unactualized potential of the fundamental shapes (as in *Vyrsa* and *Alwha*). We are led to imagine what compositions might be constituted by the multiple forms randomly floating on Kahn's primal water. This is his midrash on the Divine instructions of *tadshe* (sprout), *yishr'tzu* (teem), and *totze* (bring forth).

Creation requires both the emergence of essential biotic forms and the free replication of those shapes and forms. But in Tobi Kahn's world of creation there is also an awareness of the need for boundaries. Without such limits, the most prolific and most powerful of the shapes would displace all others, and the world's rich diversity would be

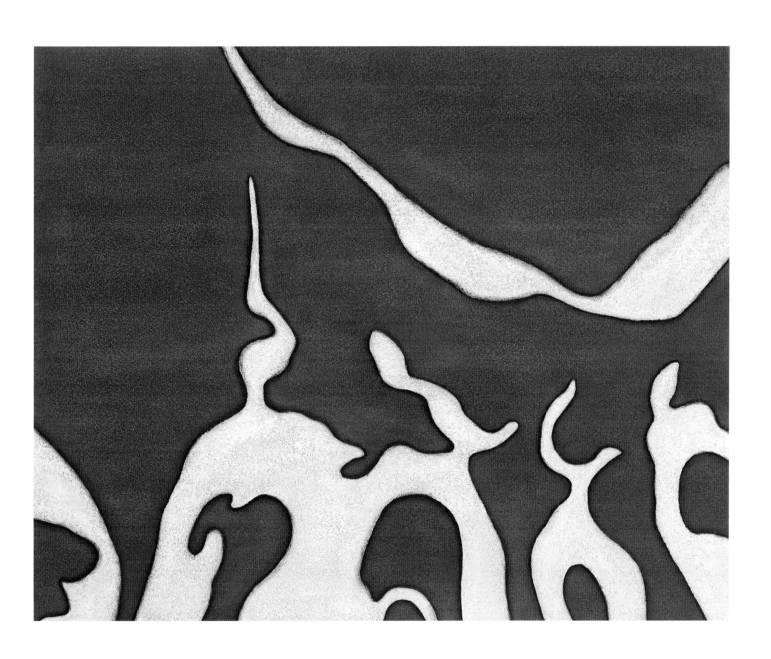

RUOATA cat. 36

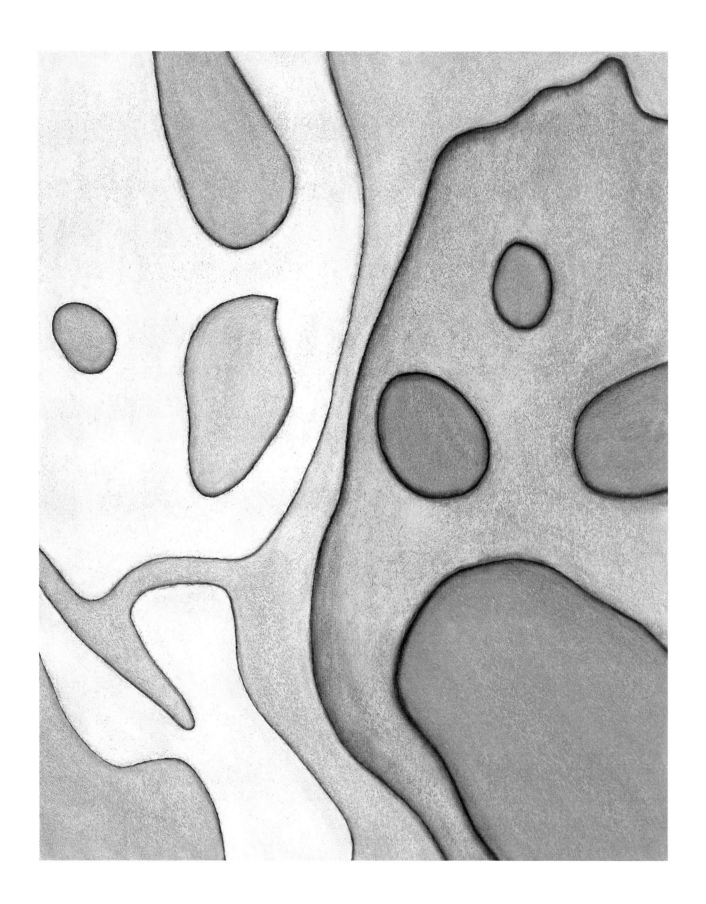

V Y R S A cat. 14

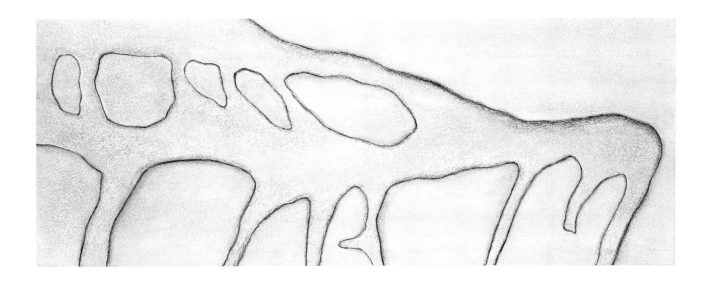

diminished. And so, many of these works convey the varied ways of achieving boundaries to untrammeled expansion.

Sometimes limits are set by the simple separation of like or diverse forms, a clearly demarcated boundary between them (as in *Jama*). In other works the limit is enforced by a barrier unlike either of the forms that it separates (as in *Rabhu*). In still others, the boundary is established by containing the forms within an encircling shape (as in *Uam-Mana*). Consistent with Kahn's perception of the creative process, boundaries are not barriers against which the shapes do battle. There is no deep resistance to the establishment of these limits. On the contrary, the boundaries free the contained forms to be themselves, eliminating the struggle for survival and supremacy that might easily be depicted in alternative conceptions of creation. Thus, Kahn offers us midrash on the biblical words *vayavdel* (divided), *vayiten* (placed), and *yikavu* (gathered).

The verbs that appear most frequently in the biblical narrative of creation are those that describe Divine speech: *vayomer* (said), *vayikra* (called), and *veyevarech* (blessed). The mystery of communication through sound symbols is amplified for us by Kahn's practice of assigning sounds rather than words as titles of his works. In this exhibition the sounds offer a sense of pre-meaning; the shapes and forms do not yet have a fixed place in the world of human function. The objects, like the sounds, are primal shapes to which human beings can assign meaning and purpose.

Yet we cannot resist hearing subconscious associations in the titles of some of these works. *Tanah* sounds strikingly like the Hebrew acrostic for the three segments of the Jewish Bible: Pentateuch, Prophets, and Writings. Is it accidental that the work shows three

powerful colors encircling, moving outwards, with streaks of interpenetration? Does *Ysra* evoke the Jewish people (*yisrael*), bereft of the presence of God (*El*), in a barren tree at dusk—or is it the verge of dawn? One work is entitled *Rekh-Eym*, suggesting the Hebrew word meaning womb, a shape found in many works in this exhibition. Sometimes we even hear the sound of a girl's name associated with a well-developed fetal form.

These suggestive sounds do not resolve the mystery; rather, they invite us into creative engagement with the relationship among form, color, and sound. The spiritual nature of the visual dimension is augmented by its association with the viewer's struggle to pronounce and interpret the sound, to name the reality. The multi-sensory nature of Kahn's work is thus intensified. Color and form engage our visual capacity; the layered, three-dimensional quality of the work makes us yearn to touch it, to feel its creative building up; while we make and hear sounds that increase our awareness of the potential communication of meaning.

Seven times in the narrative of creation the Bible declares that God saw (*vayar*—perceived) "that it was good." The culmination of the process of physical creativity requires evaluation, to determine whether the spiritual purposes that animate all of creation were achieved. We are challenged to ask ourselves whether the productive process resulted in the amplification of goodness.

Tobi Kahn's micro-cosmic evocation of the creation of the cosmos bears within itself an evaluation of the goodness of all being. His is a deeply optimistic and spiritual vision. The unfolding of the material world is not violent. Creation is God's gentle and loving caressing of forms and shapes into their maximum potential for generating good in the world. The dialectic of division and of setting boundaries is the manifestation of the cooperative spirit among the elements of creation, willing to self-limit in order to achieve the greater good. The artist's awareness of the Divine desire for the actualization of goodness in the material world suffuses even the natural tensions of the creative process.

This exhibition deepens our insight into and understanding of the biblical narrative of creation, while challenging us to bring those awarenesses to our own productive processes in the real world—as Kahn has brought them to his work.

SAUL J. BERMAN

———

Rabbi Saul J. Berman is Associate Professor of Jewish Studies at Stern College of Yeshiva University. He serves as an Adjunct Professor at Columbia University School of Law and is Director of Edah.

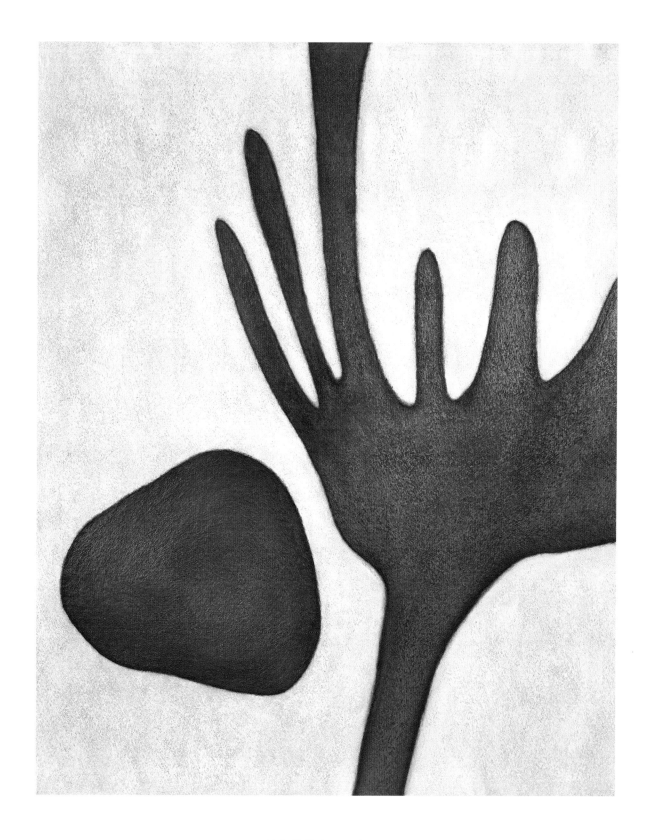

K A D R A cat. 32

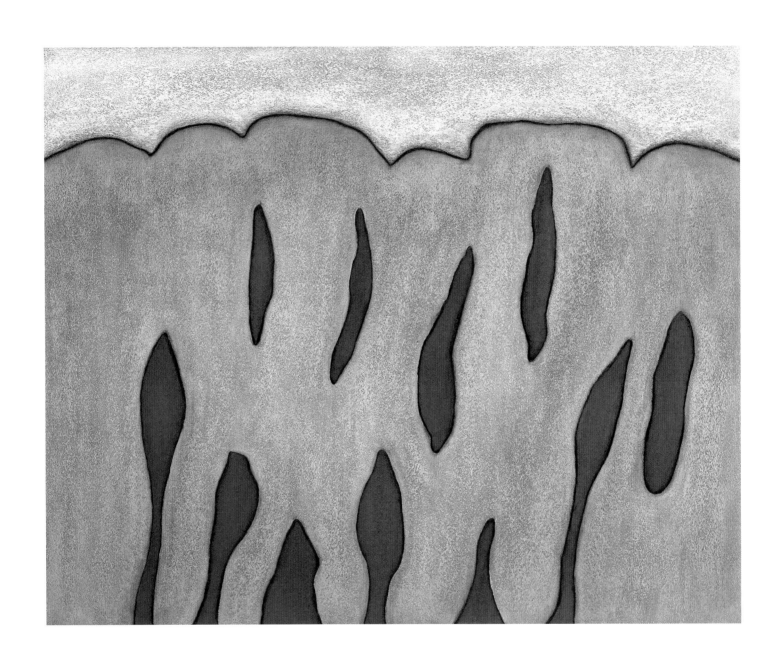

NADIRH cat. 6

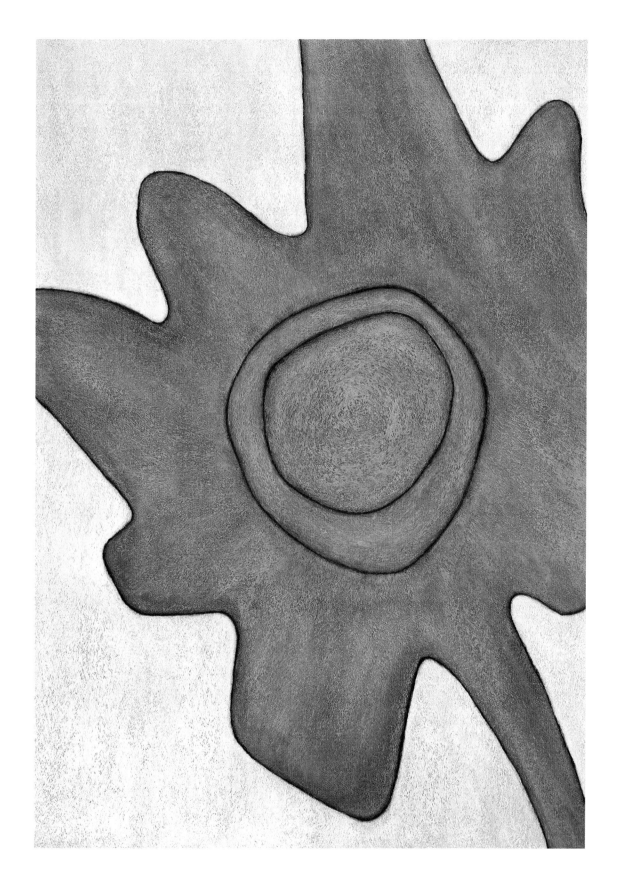

AAHPA cat. 29

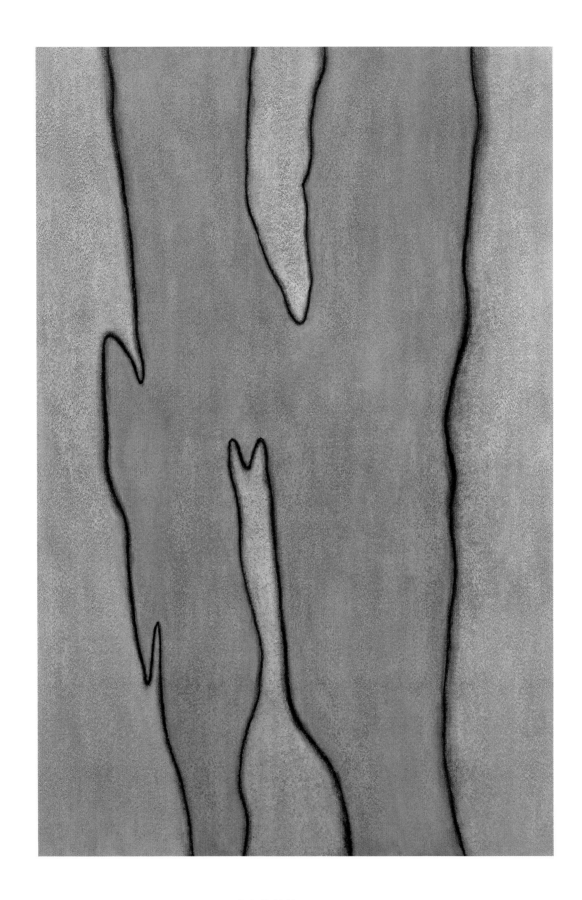

RABHU cat. 31

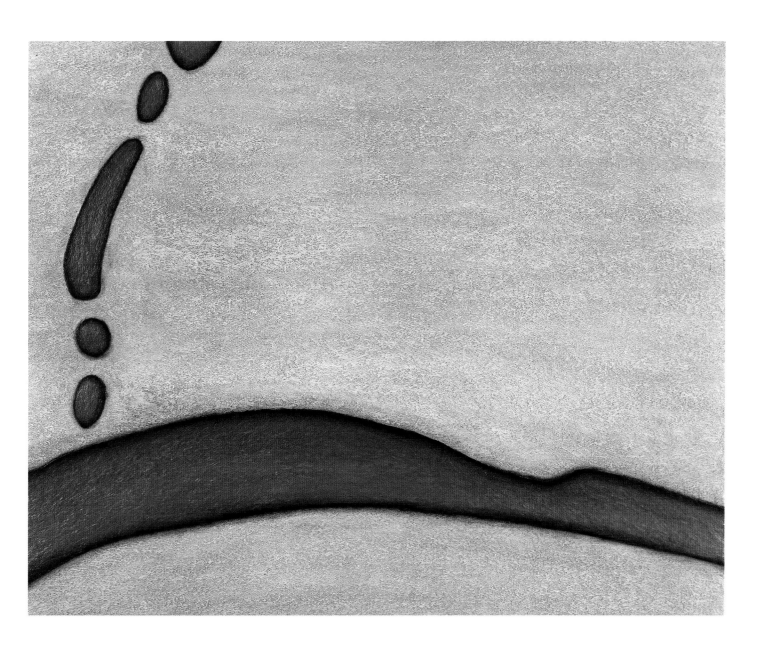

Y Y N cat. 21

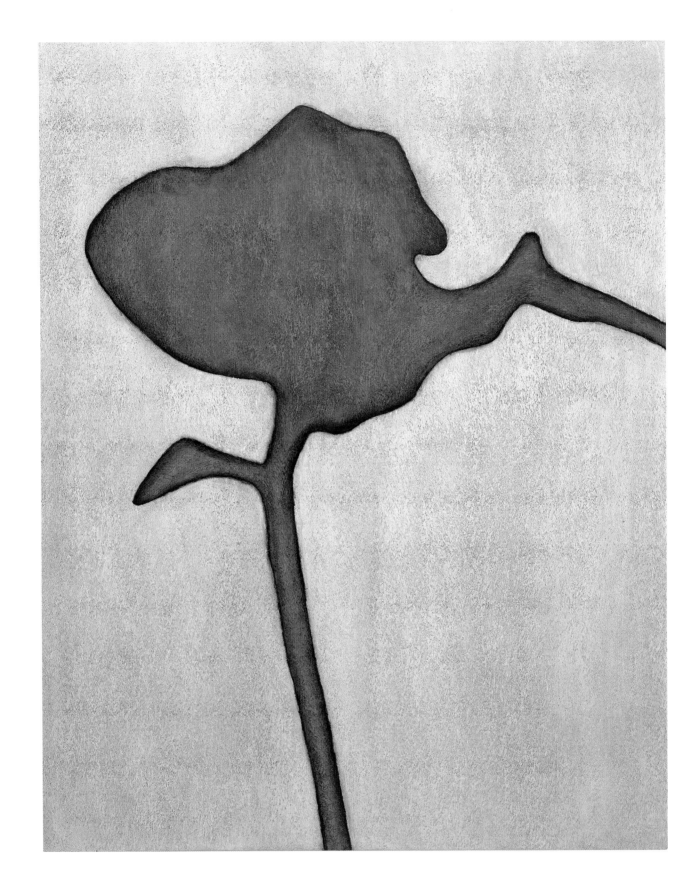

TYLA cat. 16

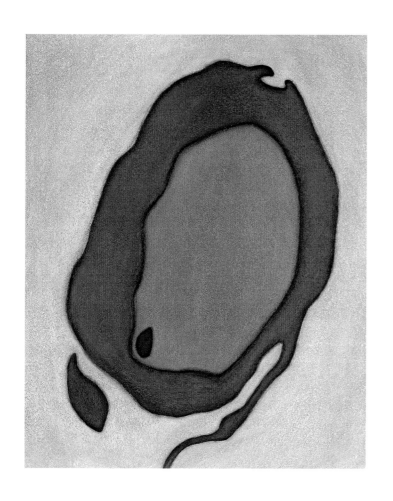

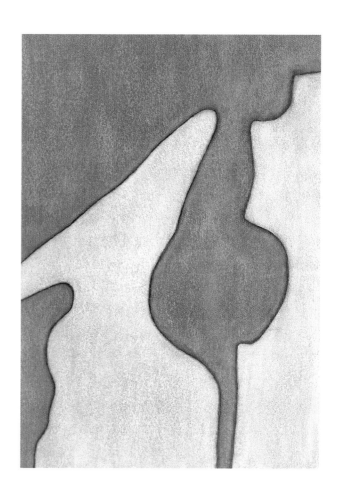

T A N A H cat. 11 I C I A N I I cat. 9

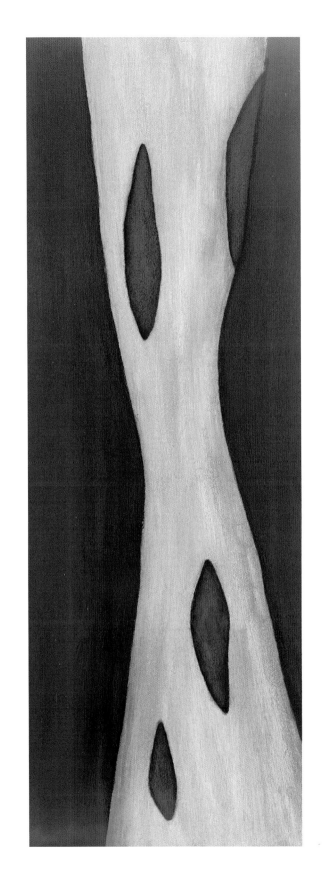

NEBILA cat. I

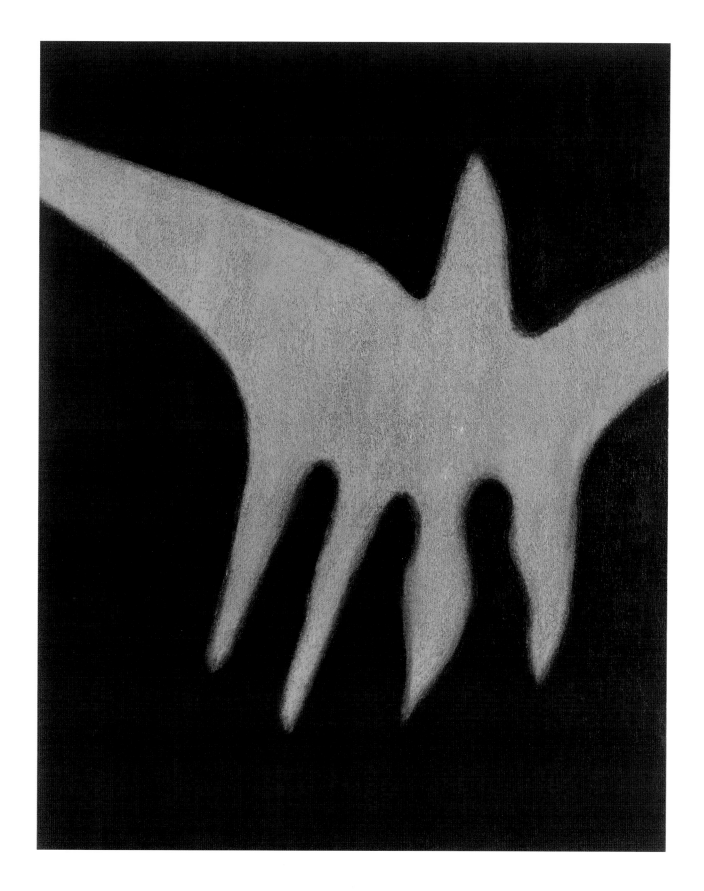

LUZZAN cat. 3

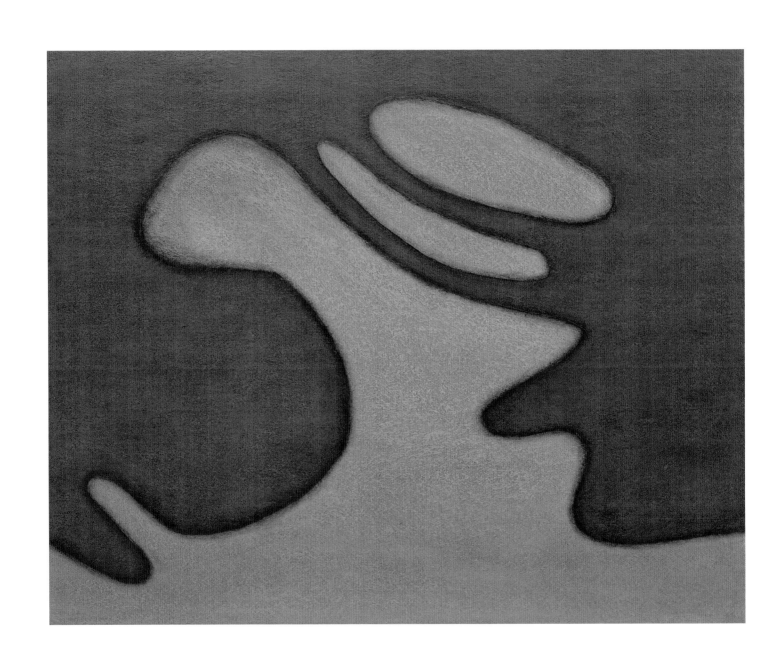

KHIMH cat. 18

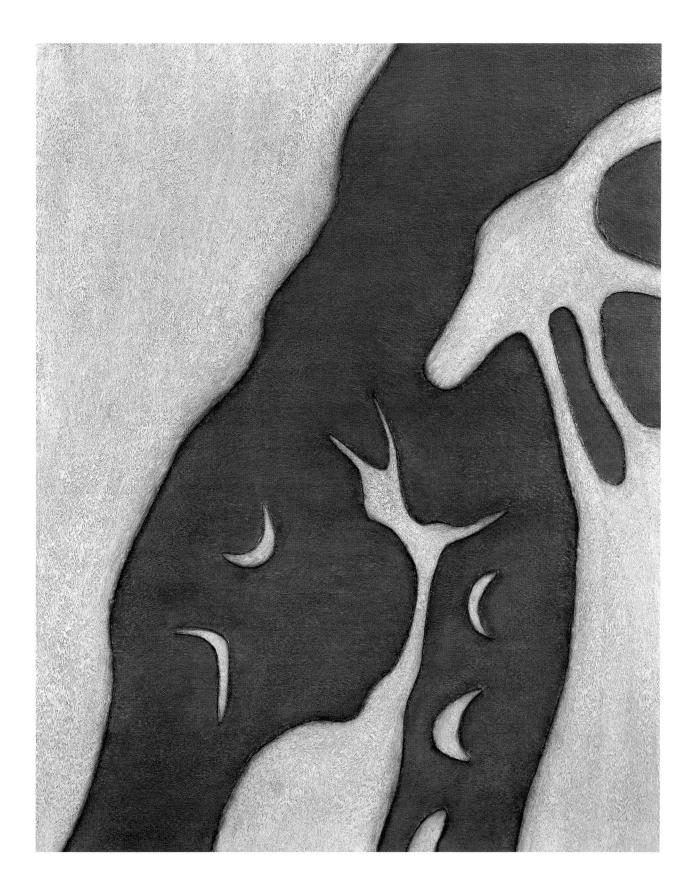

JYA cat. 33

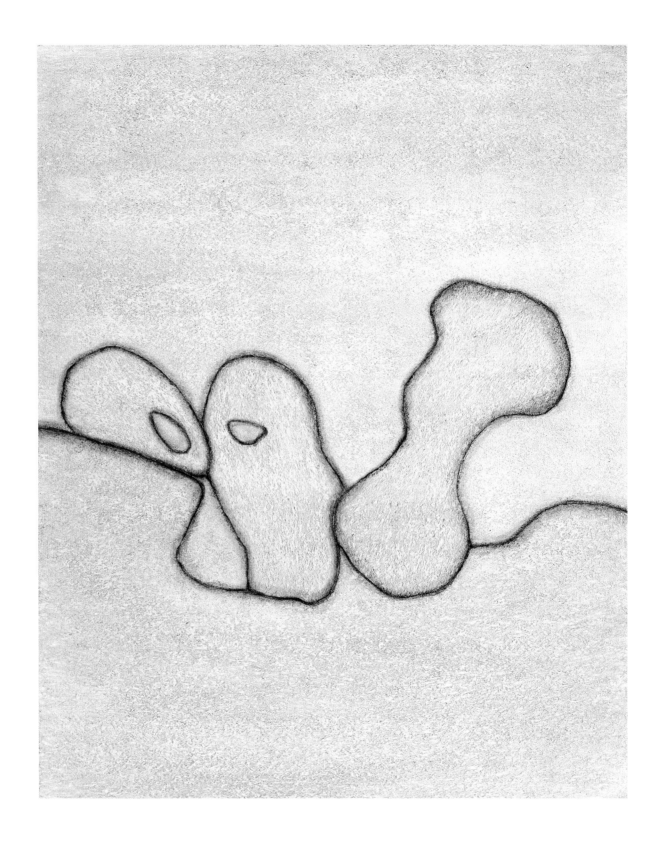

MALIN cat. 12

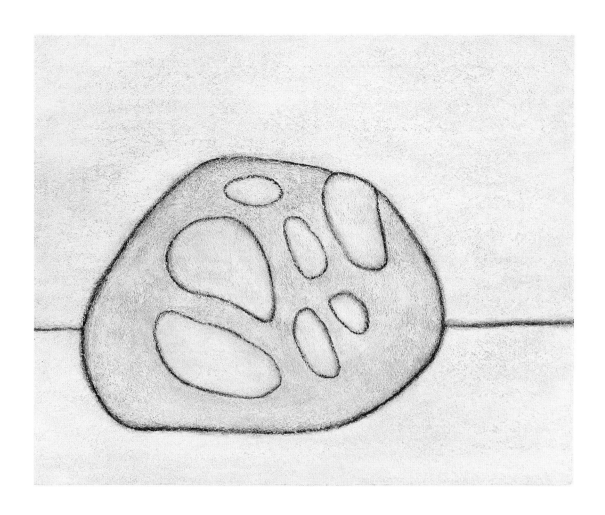

LEI-ORNA cat. 13

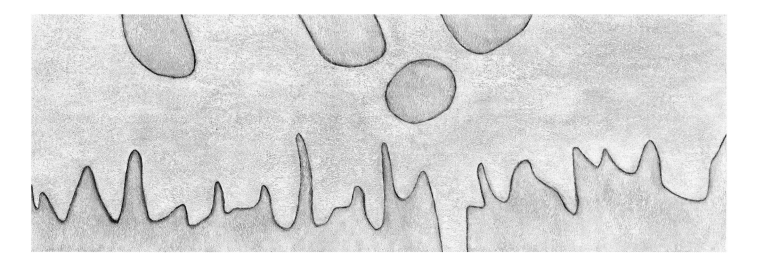

AHVIR cat. 15

CATALOGUE OF THE EXHIBITION

―――――

1

Nebila, 1990
Acrylic on canvas over wood
70 x 24 x 2 inches
Private collection
Illustrated p. 48

2

Almah II, 1993
Acrylic on canvas over wood
58 x 72 x 2½ inches
Private collection
Illustrated p. 19

3

Luzzan, 1993
Acrylic on canvas over wood
50 x 40 x 2 inches
Private collection
Illustrated p. 49

4

Dariah, 1993
Acrylic on canvas over wood
50 x 40 x 2 inches
Private collection
Illustrated p. 27

5

Rekh-Eym, 1994
Acrylic on wood
8⅛ x 10⅛ x 2½ inches
Private collection
Illustrated p. 28

6

Nadirh, 1995
Acrylic on canvas over wood
48 x 60 x 2½ inches
Private collection
Illustrated p. 42

7

Alwha, 1996
Acrylic on wood
18 x 48 x 2 inches
Collection of Mark A. Bilski
Illustrated p. 39

8

Ycali II, 1996
Acrylic on wood
11 x 8 x 2¾ inches
Private collection
IIllustrated p. 9

9

Ician II, 1996
Acrylic on wood
11 x 8 x 2¾ inches
Private collection
Illustrated p. 47

10

Qinta, 1996
Acrylic on wood
22 x 26 x 2¼ inches
Ellen and Herbert Kahn
Illustrated p. 6

11

Tanah, 1997
Acrylic on canvas over wood
36 x 29 x 2½ inches
Collection of Leading Executive
Organizations 100, Inc.
Illustrated p. 47

12

Malin, 1997
30 x 24 x 2½ inches
Private collection
Illustrated p. 52

13

Lei-Orna, 1999
Acrylic on wood
24¼ x 29¾ x 2½ inches
Collection of the artist
Illustrated p. 53

14

Vyrsa, 2001
Acrylic on canvas over wood
72 x 58 x 2½ inches
Collection of the artist
Illustrated p. 38

15

Ahvir, 2001
Acrylic on canvas over wood
24¼ x 72¼ x 2¾ inches
Collection of the artist
Illustrated p. 53

16

Tyla, 2001
Acrylic on canvas over wood
50¼ x 40¼ x 2½ inches
Collection of the artist
Illustrated p. 46

17

Alkah, 2001
Acrylic on canvas over wood
24¼ x 72¼ x 2¾ inches
Collection of the artist
Illustrated p. 20

18

Khimh, 2001
Acrylic on canvas over wood
40¼ x 50¼ x 2¾ inches
Collection of the artist
Illustrated p. 50

19

Yrth, 2001
Acrylic on canvas over wood
60¼ x 48¼ x 2¾ inches
Collection of the artist
Illustrated p. 56

20

Moea, 2001
Acrylic on canvas over wood
50¼ x 40¼ x 2¾ inches
Collection of the artist
Illustrated p. 24

21

Yyn, 2001
Acrylic on canvas over wood
40¼ x 50¼ x 2¾ inches
Collection of the artist
Illustrated p. 45

22

Jama, 2001
Acrylic on canvas over wood
60¼ x 48¼ x 2¾ inches
Collection of the artist
Illustrated p. 31

23

Ykhon, 2001
Acrylic on canvas over wood
60¼ x 48¼ x 2¾ inches
Collection of the artist
Illustrated p. 2 (frontispiece)

24

Nahn, 2001
Acrylic on canvas over wood
60¼ x 44¼ x 2¾ inches
Collection of the artist
Illustrated p. 15

25

Ahlom, 2001
Acrylic on canvas over wood
48¼ x 44¼ x 2⅝ inches
Private collection
Illustrated p. 11

26

Aacha, 2001
Acrylic on canvas over wood
64¼ x 48¼ x 2¾ inches
Collection of the artist
Illustrated p. 23

27

Elyc, 2001
Acrylic on canvas over wood
58¼ x 72¼ x 2¾ inches
Collection of the artist
Illustrated p. 16

28

Yde, 2001
Acrylic on canvas over wood
60¼ x 44¼ x 2¾ inches
Collection of the artist
Illustrated on cover

29

Aahpa, 2001
Acrylic on canvas over wood
60¼ x 44¼ x 2¾ inches
Collection of the artist
Illustrated p. 43

30

Ysra, 2001
Acrylic on canvas over wood
50¼ x 40¼ x 2¾ inches
Collection of the artist
Illustrated p. 12

31

Rabhu, 2002
Acrylic on canvas over wood
72 x 48 x 2½ inches
Collection of the artist
Illustrated p. 44

32

Kadra, 2002
Acrylic on canvas over wood
60¼ x 48¼ x 2¼ inches
Collection of the artist
Illustrated p. 41

33

Jya, 2002
Acrylic on canvas over wood
50¼ x 40¼ x 2⅝ inches
Collection of the artist
Illustrated p. 51

34

Ortya, 2002
Acrylic on canvas over wood
40¼ x 50¼ x 2⅝ inches
Collection of the artist
Illustrated p. 34

35

Uam-Mana, 2002
Acrylic on canvas over wood
50¼ x 40¼ x 2⅝ inches
Collection of the artist
Illustrated p. 33

36

Ruoata, 2002
Acrylic on canvas over wood
48¼ x 60¼ x 2⅝ inches
Collection of the artist
Illustrated p. 37

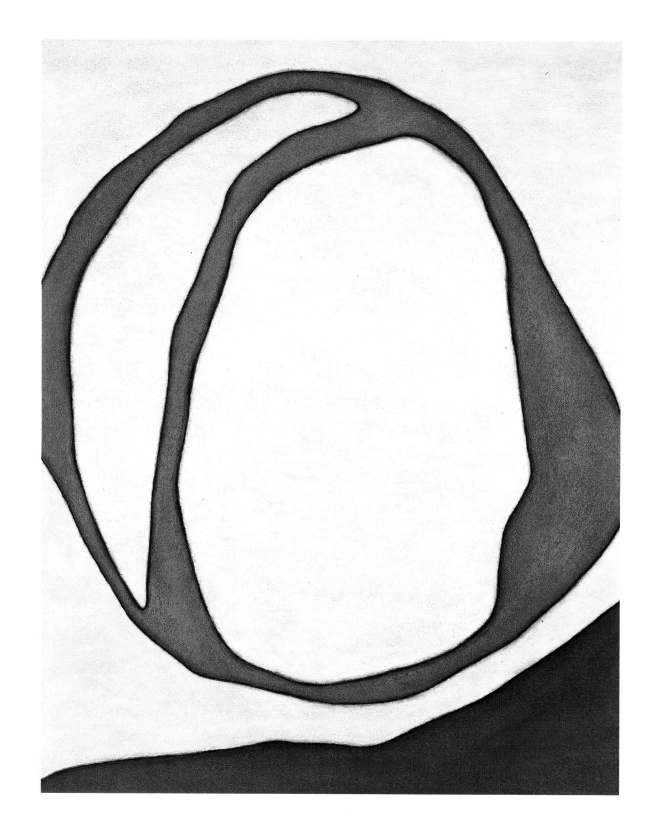

YRTH cat. 19

CHRONOLOGY

———

1952	Born May 8, New York. Son of Ellen (neé Schapiro) and Herbert Kahn, and the younger brother of Felice Kahn (now Felice Kahn Zisken).
1958–1966	Attends Samson Raphael Hirsh Elementary School, New York.
1966–1970	Attends Manhattan Talmudic Academy/Yeshiva University High School, New York.
1970–1971	Attends Tel Aviv University, Israel.
1971–1974	Travels extensively through the Middle East, Europe, Australia, and Africa. Studies at Yeshivat Kerem B'Yavneh and Yeshivat Har Etzion, Israel.
1974–1976	Graduates from Hunter College, New York, with B.A., summa cum laude and kappa pi. Receives the Estelle Levy Award for Outstanding Merit in Art and the Herman Muehlstein Foundation Graduate School Award.
1976–1978	Enters Pratt Institute, Masters Degree Program, Brooklyn, New York. Receives internship, Art Program, Pratt Institute (1977). Receives Pratt Institute Fellowship Award in Painting (1978). Graduates from Pratt Institute with M.F.A. in 1978.
	Adjunct Lecturer, New York Technical College, City University of New York, Brooklyn, New York (through 1985).
	Establishes and teaches in art department at Manhattan Hebrew High School, Riverdale, New York (through 1980).
	Leases studio in Long Island City, New York, with four other artists, including painter Sharon Florin, with whom he continues to share a studio.
1979	First solo exhibition at Fordham University, New York.
	Artist-in-residence, Kaufman Cultural Center, New York (through 1985).
1981	First museum group show at The Queens Museum, Flushing, New York.

1983	Solo exhibitions, Althea Viafora Gallery, New York (1984, 1986, 1987, 1989).
	Conducts gallery and art museum lecture series for a group of collectors through the Jewish Community Center on the Palisades, New York (until the present).
1984	Solomon R. Guggenheim Museum, New York, is gifted *Iza II* for its permanent collection.
1985	Seventeen paintings and two sculptures included in *New Horizons in American Art: 1985 Exxon National Exhibition*, Solomon R. Guggenheim Museum, New York.
	Visiting artist, Mishkenot Sha'Ananim, Jerusalem, Israel.
1986	Marries writer Nessa Rapoport, April 10.
	Teaches painting at the School of Visual Arts, New York (until the present).
	Hoya, an edition of thirty-six etchings, is commissioned and published by The Jewish Theological Seminary of America, New York.
1988	Solo exhibitions, Mary Ryan Gallery, New York (1991, 1993, 1995); and Gloria Luria Gallery, Bay Harbor Islands, Florida (1990, 1992).
	Creates set for Solomons Dance Company, *Aspen Grove* and *Boneyard*, premiered at The Joyce Theater and St. Mark's Church, New York.
	Son Joshua is born, May 10.
1989–1990	Creates set for Elizabeth Swados, *Song of Songs*, premiered at Central Synagogue, New York; and for Muna Tseng, *Aluat-El*, premiered at Riverside Park, New York.
	Creates set for Elizabeth Swados, *Jonah*, premiered at The Public Theater, New York; and for Muna Tseng, *Ways, Shrines, Mysteries*, premiered at Florence Gould Hall, New York.
1991–1993	Daughter Mattie is born, March 17, 1992.
	Creates first monumental outdoor sculpture, *Shalev*, bronze and stone, commissioned by Jane Owen and the Robert Lee Blaffer Trust for New Harmony, Indiana. Designs the label for New Amsterdam Brewing Company, Winter Anniversary Limited Edition.
1994–1996	Creates *The Twelve Tribes* and *Creation of the World*, a series of twelve works on paper and one painting for the Jewish Family Congregation, South Salem, New York, commissioned by the Nathan Cummings Foundation, New York. Creates *Eyda*, an installation of seven paintings, commissioned by Mitchell and Company, Boston, Massachusetts. *Rigu-Saar* appears on the cover of *Collected Writings of Adrienne Rich* (New York: Quality Paperback Book Club, 1994).
	Study for Doekh appears on the cover of *The American Journal of Pathology* (January 1996). Originally commissioned by Dr. Mark Tykocinski for his article, "Antigen-Presenting Cell Engineering."

1997	Solo museum exhibition, *Tobi Kahn: Metamorphoses*, curated by Peter Selz, with accompanying catalogue including essays by Peter Selz, Dore Ashton, and Michael Brenson, begins traveling to eight museums around the United States.
	Creates *Gan Hazikaron: Garden of Remembrance*, an outdoor installation of six bronze sculptures as a Holocaust memorial for the Jewish Community Center on the Palisades, New Jersey, commissioned by Holocaust survivors and their children.
	Mezuzah commissioned for front door of the Museum of Jewish Heritage, Battery Park City, New York, 1997.
1998	Daughter Doria Bella is born, February 3.
1999	Solo exhibition, *Avoda: Objects of the Spirit*, a traveling museum exhibition curated by Laura Kruger, opens at the Hebrew Union College, New York, beginning a five-year national tour.
	Creates *Sky and Water*, a nine-painting installation, for the exhibition *Landscape at the Millennium*, curated by Douglas Dreishpoon, with accompanying catalogue, at the Albright-Knox Art Gallery, Buffalo, New York.
2000	Receives 2000 Alumni Achievement Award from Pratt Institute, Brooklyn, New York.
	Creates an outdoor installation that includes bronzes and landscaping as a Holocaust memorial for the Lawrence Family Jewish Community Center of San Diego County, La Jolla, California.
	Receives grant from the Charles H. Revson Foundation for *Avoda: Objects of the Spirit* project.
	Receives grant from the Covenant Foundation for *Avoda: Objects of the Spirit* project.
	Solo museum exhibition, *Tobi Kahn: Correspondence*, curated by Mark A. White, with accompanying catalogue, begins traveling to five museums in the United States.
2001	Creates meditative room for the HealthCare Chaplaincy, New York, consisting of nine murals and sculptural furniture.
	Solo exhibition, *Tobi Kahn: Heads*, curated by Peter Selz, with accompanying catalogue, Rubelle and Norman Schafler Gallery, Pratt Institute, Brooklyn, New York.
2002	Solo exhibition, *Tobi Kahn: Microcosmos*, curated by Reba Wulkan, with accompanying catalogue, Yeshiva University Museum in Chelsea, New York.
2003	Solo exhibition, *Sky and Water Series*, curated by Dede Young, with accompanying catalogue, Neuberger Museum of Art, Purchase College, Purchase, New York.

SELECTED EXHIBITIONS

———

1979 Fordham University, New York.

1980 Robert Brown, New York.

1981 Blumberg Harris, New York.

1983 Althea Viafora Gallery, New York (1984, 1986, 1987, 1989).

1985 Bernard Jacobson, Ltd., Los Angeles, California.

 J. Robert Fisher Hall at Mishkenot Sha'Ananim, Jerusalem, Israel.

1987 Krygier/Landau Contemporary Art, Los Angeles, California.

 John Berggruen Gallery, San Francisco, California.

 Philadelphia Museum of Judaica, Philadelphia, Pennsylvania.

1988 Harcus Gallery, Boston, Massachusetts.

 Cleveland Center for Contemporary Art, Cleveland, Ohio (1993).

 Mary Ryan Gallery, New York (1991, 1993, 1995, 1997).

 Gloria Luria Gallery, Bay Harbor Islands, Florida (1990, 1992).

1990 Marilyn Butler Fine Art, Scottsdale, Arizona.

1993 Thomson Gallery, Minneapolis, Minnesota.

 Litwin Gallery, Wichita, Kansas.

1994 Allene Lapides Gallery, Santa Fe, New Mexico.

1995 Andrea Marquit Fine Arts, Boston, Massachusetts (1998).

1996 The Warehouse Gallery, Lee, Massachusetts.

 Harmon-Meek Gallery, Naples, Florida (2000).

1997 The Hyde Collection, Glens Falls, New York.

 M. Louise Aughinbaugh Gallery, Grantham, Pennsylvania.

Tobi Kahn: Metamorphoses. Curated by Peter Selz, traveled through 1999 to the Weatherspoon Art Gallery, Greensboro, North Carolina; Trout Gallery, Carlisle, Pennsylvania; MOCRA, St. Louis, Missouri; Thomas J. Walsh Gallery, Fairfield, Connecticut; Colby College Museum of Art, Waterville, Maine; The Museum of Fine Arts, Houston, Texas; Judah L. Magnes Museum, Berkeley, California; Skirball Cultural Center, Los Angeles, California.

1998 Hooks-Epstein Gallery, Houston, Texas.

1999 Albright-Knox Art Gallery, Buffalo, New York.

Avoda: Objects of the Spirit. Curated by Laura Kruger, a five-year traveling museum exhibition, originated at Hebrew Union College, New York.

2000 *Tobi Kahn: Correspondence.* Curated by Mark A. White, travels through 2003 to Edwin A. Ulrich Museum of Art, Wichita, Kansas; Holtzman Gallery, Towson University, Towson, Maryland; The Evansville Museum of Arts and Science, Evansville, Indiana; The Sheldon Swope Art Museum, Terre Haute, Indiana.

2001 Pratt Institute Art Gallery, Brooklyn, New York.

2002 Yeshiva University Museum in Chelsea, New York.

SELECTED GROUP EXHIBITIONS

1980 Zolla/Lieberman, Chicago, Illinois.

1981 *Annual Juried Exhibition*, Queens Museum, Flushing, New York. Curated by John Perreault (catalogue).

1983 *Saints*, Harm Boukaert Gallery, New York.

1984 *From the Abstract to the Image*, Oscarsson Hood Gallery, New York.

2500 Sculptors Across America, Civilian Warfare, New York.

1985 *Contemporary Sculpture on a Pedestal.* Originated at the Moody Gallery, University of Alabama. Traveled to University Galleries, University of South Florida; and Huntsville Museum of Art, Huntsville, Alabama. Curated by Susan L. Halper (catalogue).

New Horizons in American Art: 1985 Exxon National Exhibition, Solomon R. Guggenheim Museum, New York. Curated by Lisa Dennison (catalogue).

The Doll and Figurine Show, The Hillwood Art Gallery, Long Island University, New York. Curated by Judy Collischan Van Wagner and Carol Becker Davis (catalogue).

Between Drawing and Sculpture, Sculpture Center, New York. Curated by Douglas Dreishpoon (catalogue).

Drawings, Cleveland Center for Contemporary Art, Cleveland, Ohio.

1986 *Anchorage/New York: Small Sculpture*, Visual Arts Center of Anchorage, Anchorage, Alaska. Curated by David Donihue (catalogue).

Jewish Themes: Contemporary American Artists Part II, The Jewish Museum, New York. Curated by Susan T. Goodman (catalogue).

Landscape in the Age of Anxiety, Lehman Art College, Bronx, New York. Curated by Nina Castelli Sundell. Traveled to Cleveland Center for Contemporary Art, Ohio (catalogue).

A View of Nature, The Aldrich Museum, Ridgefield, Connecticut. Curated by Ellen O'Donnell (catalogue).

1987 *Emerging Artists 1978–1986: Selections from the Exxon Series*, Solomon R. Guggenheim Museum, New York. Curated by Diane Waldman.

The New Romantic Landscape, Whitney Museum of American Art, Fairfield County Branch, Stamford, Connecticut.

Sacred Spaces, Everson Museum of Art, Syracuse, New York. Curated by Dominique Nahas (catalogue).

Contemporary American Landscape: Reflections of Social Change, Summit Art Center, Summit, New Jersey. Curated by Nancy Cohen, Kiku Fukui and Liz Kelsey.

1988 *Art on Paper*, Weatherspoon Art Gallery, The University of North Carolina at Greensboro, North Carolina (catalogue).

Dia de los Muertos, Alternative Museum, New York (catalogue).

Golem! Danger, Deliverance and Art, The Jewish Museum, New York. Curated by Emily Bilski (catalogue).

Annual Juried Show, Queens Museum, New York. Curated by Irving Sandler (catalogue).

1989 *Rugged Terrain: Landscape Painting*, Shea & Beker, New York.

Contemporary Landscape: Five Views, Waterworks Visual Arts Center, Salisbury, Virginia. Curated by John Moore (catalogue).

Monotypes, Cleveland Center for Contemporary Art, Cleveland, Ohio.

1990 *Southeast Bank Collects: A Florida Corporation Views Contemporary Art*. Organized by the Norton Gallery of Art, West Palm Beach, Florida. Traveled to the Bass Museum of Art, Miami Beach, Florida; Museum of Fine Arts, St. Petersburg, Florida; Polk Museum of Art, Lakeland, Florida; and Samuel P. Harn Museum of Art, Gainesville, Florida (catalogue).

Horizons, Pfizer, Inc., through The Art Advisors, The Museum of Modern Art, New York.

Insistent Landscapes, Security Pacific Gallery, Los Angeles, California. Curated by Mark Johnstone (catalogue).

1991 *Retrieving the Elemental Form*, Schmidt-Bingham Gallery, New York. Traveled to Lakeview Museum of Arts and Science, Peoria, Illinois; and Fresno Art Museum, Fresno, California (catalogue).

Playing Around: Toys by Artists, DeCordova Museum and Sculpture Park, Lincoln, Massachusetts.

1992 *Off the Wall*, Cleveland Center for Contemporary Art, Cleveland, Ohio.

ECO-92, Museum of Modern Art, Rio de Janeiro, Brazil (catalogue).

Contemporary American Painting and Sculpture, Art in Embassies, U.S. Department of

State, American Embassy, Tel Aviv, Israel. Curated by Louise Eliasof and Renne Du Pont Harrison.

1993 *Timely Timeless*, Aldrich Museum, Ridgefield, Connecticut. Curated by Douglas F. Maxwell (catalogue).

25 Years, Cleveland Center for Contemporary Art, Cleveland, Ohio. Curated by Majorie Talalay.

Aspects of Sculpture, The Ulrich Museum of Art, Wichita, Kansas. Curated by Donald Knaub.

Sanctuaries: Recovering the Holy in Art, Museum of Contemporary Religious Art, Saint Louis University, St. Louis, Missouri. Curated by Terrence Dempsey.

1994 *A Bouquet for Juan*, Nancy Hoffman Gallery, New York.

Landscape Not Landscape, Gallery Camino Real, Boca Raton, Florida. Curated by Douglas F. Maxwell (catalogue).

1995 *Art on Paper*, The Weatherspoon Art Gallery, The University of North Carolina at Greensboro, North Carolina (catalogue).

Never Again, The Cathedral of St. John the Divine, New York. Curated by Noga Garrison.

Painting North, Art in Embassies, U.S. Department of State, American Embassy, Santiago, Chile (catalogue).

1996 *By the Sea*, Fotouhi Cramer Gallery, New York. Curated by Robert G. Edelman and Renee Fotouhi.

Destiny Manifest: American Landscape Painting in the Nineties, The Samuel P. Harn Museum of Art, Gainesville, Florida. Curated by Dede Young (catalogue).

The Figure in 20th Century Sculpture, Edwin A. Ulrich Museum of Art, Wichita, Kansas. Traveled to eleven museums in the United States.

1997 *Aerial Perspectives*, DC Moore Gallery, New York, and the Kendall Gallery, Miami, Florida. Curated by Margaret Matthews-Berenson.

Vertical Painting, P.S. 1 Contemporary Art Center, Long Island City, New York. Curated by Alanna Heiss.

1998 *Contemporary Landscape Artists*, Elise Goodheart Fine Arts, Sag Harbor, New York.

1999 *Waxing Poetic*, The Montclair Art Museum, Montclair, New Jersey, and the Knoxville Museum of Art, Knoxville, Tennessee (catalogue).

2000 *Living In The Moment*, Skirball Museum, Cincinnati, Ohio, and Hebrew Union College, New York. Curated by Laura Kruger.

Ethereal and Material, Delaware Center for the Contemporary Arts, Wilmington, Delaware. Curated by Dede Young.

2001 *Jewish Artists: On the Edge*, Yeshiva University Museum, New York. Curated by Ori Z. Soltes.

Like a Prayer, Tryon Center for Visual Art, Charlotte, North Carolina. Curated by Theodore L. Prescott.

PUBLIC COLLECTIONS

———

Baer, Marks, Upham, New York

Chase Manhattan Bank, New York

Colby College Museum of Art, Waterville, Maine

Dreyfus Corporation, New York

Edwin A. Ulrich Museum of Art, Wichita, Kansas

Exxon Corporation, Miami, Florida

Fidelity Investments Corporation, Boston, Massachusetts

Fort Wayne Museum, Fort Wayne, Indiana

The Houston Museum of Fine Arts, Houston, Texas

I.N.A. Museum, Cigna Corporation, Philadelphia, Pennsylvania

The Jewish Museum, New York

McCarter English, Newark, New Jersey

Mitchell and Company, Boston, Massachusetts

Museum of Art, Fort Lauderdale, Florida

Progressive Corporation, Cleveland, Ohio

Prudential Insurance, New York

Rose Art Museum, Brandeis University, Waltham, Massachusetts

Salomon Brothers, Inc., New York

Skadden, Arps, Slate, Neagher & Flom, New York

The Skirball Cultural Center, Los Angeles, California

The Solomon R. Guggenheim Museum, New York

Swiss Bank Corporation, New York

Weatherspoon Art Gallery, The University of North Carolina, Greensboro